W9-CGN-438

 PEGASUS
Library

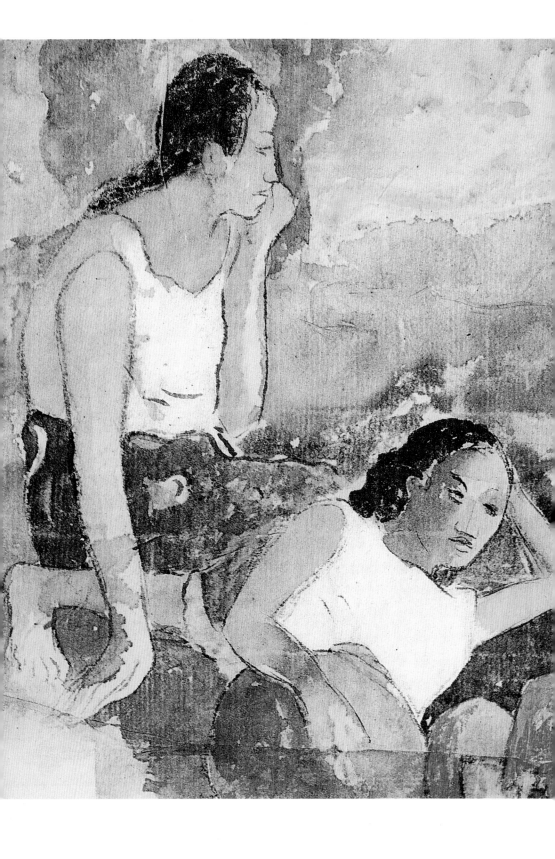

Eckhard Hollmann

Paul Gauguin

Images from
the South Seas

Prestel

Munich · London · New York

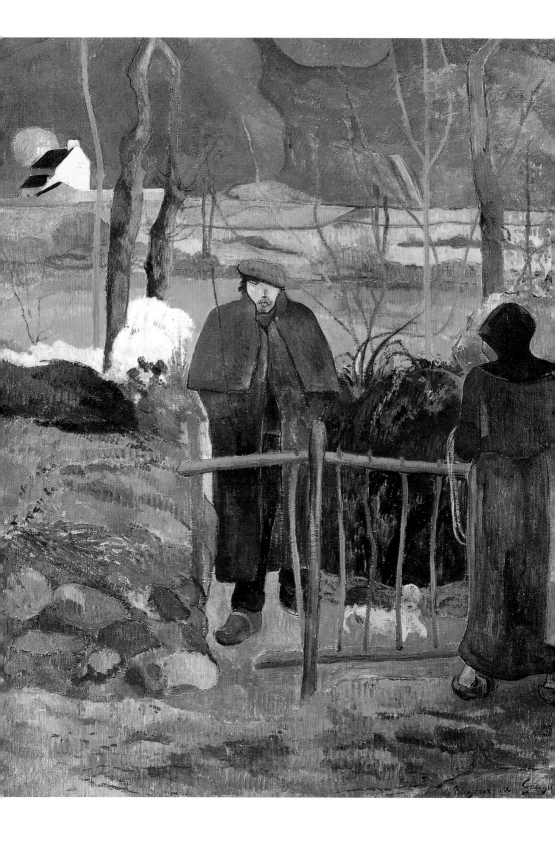

Prologue: Prior to 1890

Bonjour, Monsieur Gauguin

It is May 1890 and, as in previous years, Paul Gauguin is on his way to Brittany again. He takes lodgings in the inn owned by Marie Henry in the little fishing village of Le Pouldu, hoping for a profitable stay, working in the company of other like-minded artists. Amongst these were Meyer de Haan and Emile Bernard, as well as Charles Laval, who had accompanied him on his trip to Panama — friends and painters together, enjoying a carefree existence. Their paintings decorated the dining room. There was even a painting on the ceiling showing a goose looking for lice in a woman's hair, with the motto *Honni soit qui mal y pense*. Gauguin, too, contributed to the "decoration" of the room, pinning his painting *Bonjour, Monsieur Gauguin* to the door.[1]

Gauguin was leaving five years of turmoil behind him. Having lost his position in Bertin's Bank, he had not been able to earn enough as a painter to support his wife, Mette, and their five children, even in modest circumstances. The move from Paris to Rouen in 1884 had not helped either — the hoped-for commissions for portraits failed to materialize. The situation went from bad to worse and the couple decided to move to Copenhagen, where Mette's family lived. Gauguin's intention was to work there as the representative of a French firm of linen makers. This plan, however, was also doomed to fail for Mette's parents made no secret of their distaste for their son-in-law, who was clearly unable to provide for his own family.

In spite of these setbacks Gauguin was not prepared to admit defeat and continued to strive to

Bonjour, Monsieur Gauguin, 1889
36 ³/₈ x 29 ¹/₈ (92.5 x 74 cm)
National Gallery, Prague

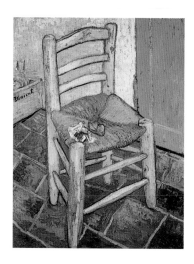

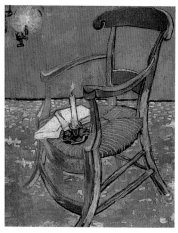

Vincent van Gogh,
Van Gogh's Chair 1888/89
36 ⅝ x 28 ⅞ in. (93 x 73.5 cm)
Tate Gallery, London, Gift of the
Courtauld Fund Trustees, 1924

Vincent van Gogh,
Gauguin's Chair, 1888
35 ⅝ x 28 ½ in. (90.5 x 72.5 cm)
Rijksmuseum Vincent van Gogh,
Amsterdam, Vincent van Gogh
Collection

make his way as an artist. This same determination had been the reason for his ultimately disappointing journey to Panama with Charles Laval. And then came 1888! In response to an invitation from Vincent van Gogh he had gone to Provence to paint with him. Their encounter had been extremely exciting at first but it soon became clear that the two were as different in their artistic views and intentions as in their life-styles. "Between our two natures, the one a regular volcano, the other boiling too, it looked as if a sort of struggle was in preparation."[2] And the more van Gogh smothered his friend with affection and the more he tried to bring Gauguin round to his way of thinking about art, the more the latter drew back. Van Gogh's mental state was deteriorating progressively — he was becoming exhausted by the feeling of daily competition with Gauguin, by their constant arguments, and by their abandoned life-style. Then, shortly before Christmas, when he threw a glass of wine at Gauguin one evening in an inn and then proceeded to threaten him the next day with a razor, their friendship was finally over. Gauguin decided to leave and moved into a hotel in Arles. But this was a grave blow for van Gogh, who loved his friend despite everything, and his emotional confusion became a form of madness. With the same razor that he had used to threaten his friend he cut off his right ear and was admitted to hos-pital. Gauguin traveled back to Paris, where he sought refuge — as so often before — with his one-time colleague from the bank, Emile Schuffenecker. Later he wrote about his time together with van Gogh: "How long were we together? I can't say — have forgotten. In spite of the suddenness of the catastrophe, in spite of the fever of work that had hold of me, this time seems to me a century. Though no one had a suspicion of it, here were

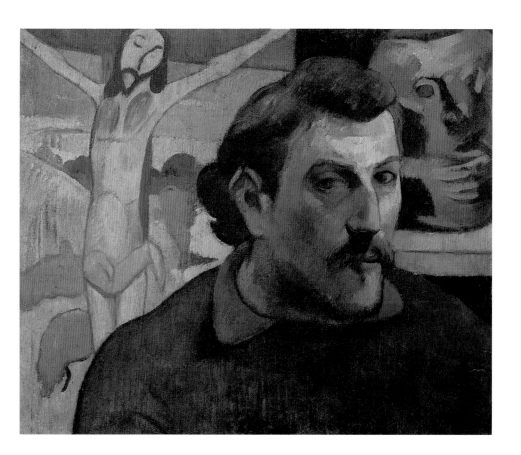

Self-Portrait with Yellow Christ , 1889
15 x 18 ¹⁄₈ in. (38 x 46 cm)
Private Collection, France

two men performing a colossal task, useful to them both. Perhaps to others as well? Some things there are that bear fruit."³

So now Gauguin was in Brittany again, and he knew that he had achieved a great deal as an artist in the last few years: he had produced masterpieces such as *The Yellow Christ*, *Self-Portrait with Yellow Christ*, *Calvary*, and *La Belle Angèle*. At long last Gauguin had found his own personal style. It had taken endless effort and it had come through tireless discussion about spiritual and artistic matters with other painters, through the inspiration of other cultures and his travels, through the beauty and austerity of the Breton landscape and the deep sense of religion of its inhabitants — but most of all through his encounter with Vincent van Gogh.

Gauguin's colors are now more vivid, people and objects have darker outlines. The very forms are tenser and more expressive. Figures burst out from within the pictures and there is tension in the juxtaposition of individual color fields and forms. Perspective, atmosphere, and the subtleties and variations of color which the Impressionists had handled with such bravura were now to count for nothing. Gauguin's concern is to portray his inner-most emotions, how he views the world, what he actually feels.

Just as Gauguin had rejected the light-filled technique of the Impressionist painters — whose prime concern was to achieve the finest nuances of color in their representation of atmosphere, space, and light — so now in turn artists such as Pissarro and Monet wanted nothing to do with him. Above all they decried him for having reintroduced mysticism and the mind back into art — elements which the Impressionists had banned outright from their works. Referring specifically to Gauguin's *Vision after the Sermon*, Pissarro wrote: "The Japanese practiced this kind of art, as did the Chinese, and their results are unadulterated Nature, but you see, they are not Catholic and Gauguin is. I am not taking Gauguin to task for having painted a vermilion background or two wrestling warriors and Breton peasant women in the foreground, but I am taking him to task for cribbing from the Japanese, the Byzantines, and others besides."[4]

On the other hand, his painting had met with an altogether enthusiastic response amongst many of the Symbolist writers, notably Paul Verlaine, Charles Morice, Albert Aurier and Octave Mirbeau. They saw his style as an actual visual realization of the Symbolist manifesto which Aurier had launched in defiance of the Impressionists during 1890:

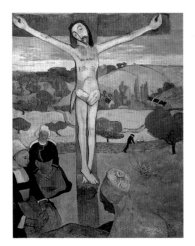

The Yellow Christ, 1889
36 ¼ x 28 ¾ in. (92 x 73 cm)
Albright Knox Art Gallery, Buffalo, New York, General Purchase Foundation

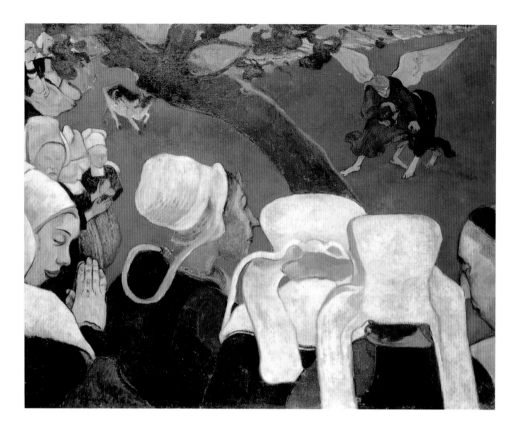

"An artwork must be:
1. Ideistic — its sole ideal is to express an idea.
2. Symbolist — as it expresses this through form.
3. Synthetic — because it captures these forms and symbols in a broadly comprehensible manner.
4. Subjective — because what is portrayed is never seen as an object in itself but as a symbol chosen by the artist to represent an idea.
5. Decorative — because the real decorative painting of the Egyptians, and most probably of the Greeks and of primitive artists too, is simply the manifestation of subjective, synthetic, symbolist, ideistic art . . ."[5]

Vision after the Sermon, 1888
28 ¾ x 36 ¼ in. (73 x 92 cm)
National Gallery of Scotland,
Edinburgh

And it is true that these theories are amply realized in Gauguin's paintings. So it is hardly surprising that on the one hand Gauguin was denigrated as

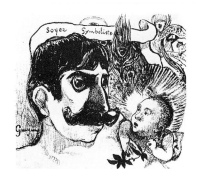

Jean Moréas,
Caricature by Gauguin, inscribed
Soyez symboliste 1891

a charlatan by Pissarro, for whom both art and modern philosophy had to be "utterly social, anti-authoritarian, and anti-mystical,"[6] while on the other hand younger artists such as Emile Bernard, Paul Sérusier, and the group of artists known as the Nabi took Gauguin as their guiding light.

So there was widespread interest when Gauguin talked in increasingly real terms of his imminent departure to the tropics. In September 1890 he wrote to Odilon Redon: "I have made the decision now and have further refined it since coming to Brittany. Madagascar is still too close to the civilized world. I shall go to Tahiti and I hope to stay there until the end of my life. I think that my art — which you appreciate — is like a young seedling and that I can cultivate it down there into something primitive and wild."[7]

In practical terms he now had two main aims: he was looking for companions to share his bold proposal to found a "tropical studio" in the South Seas and he was also looking for a way of raising the money for such an immense journey. He wrote countless letters to friends asking for support for his proposal. Just as he had done before setting off for Panama, he would describe the tropical lands that he intended to visit in the most glowing of colors. But neither Charles Laval nor Emile Bernard nor Meyer de Haan were to be won over. So this was the situation in Brittany when, in August, news of Vincent van Gogh's death reached the painters there.

Pola Gauguin, the artist's youngest son, writing in his acclaimed book about his father, gives a sensitive account of what the effect of this grave news must have been: "In reality Van Gogh's fate made a very deep impression on Gauguin. When alone with his thoughts he would often work himself up till he burst into tears, and at times he even

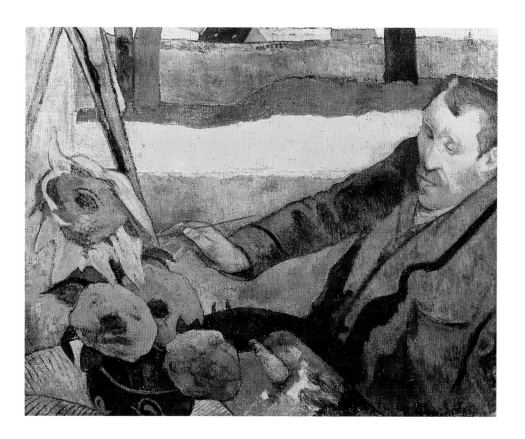

Vincent van Gogh
Painting Sunflowers
1888
28 ¾ x 35 ¾ in. (73 x 91 cm)
Rijksmuseum Vincent van Gogh,
Amsterdam

addressed an absent person earnestly and tenderly, but when faced by anything that appealed to his feelings he was shy and afraid of giving himself away. He took refuge behind a mask, which may have concealed a violent emotion, but had more the appearance of arrogance. He was unwilling to speak of those events in his life which had made a strong impression on him, particularly where an explanation or excuse for his conduct might have been called for. This silence was often interpreted as indifference. He knew that this was so and it made him persist in his silence, even when someone tried to relieve the painful situation which often arose."[8]

With the autumn came renewed hope for Gauguin of a major breakthrough and of major success. Vincent van Gogh's brother, the art-dealer Théo

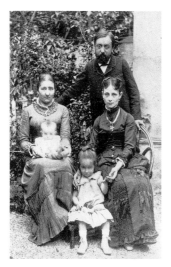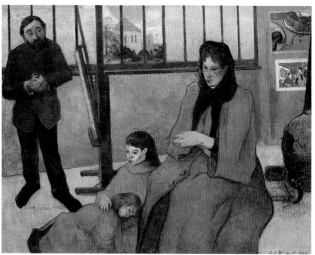

van Gogh, sent a telegram from Paris saying that he could sell all Gauguin's paintings and that his journey to the tropics was no longer in doubt. He hardly dared believe his good fortune — which indeed was not to be. Most probably affected by Vincent's suicide, Théo van Gogh too lost his sanity.

But all these bitter blows merely served to strengthen Gauguin's resolve once and for all to turn his back on Europe — which he regarded as hidebound and blind and where he felt there was no longer the slightest chance of finding even acceptable conditions for life as an artist. He now invested his entire energy in realizing his plans to leave, writing to Emile Bernard: "When will I be living in the woods at last, and be free? My God, how much longer must I wait?"[9]

The Schuffenecker Family
Photograph, c. 1888/89

The Schuffenecker Family 1889
28 ³/₄ x 36 ¹/₄ in. (73 x 92 cm)
Musée d'Orsay, Paris

Farewell, Paris!

By the autumn of 1890 Gauguin is in Paris again in the Café Voltaire, with other painters, writers, and poets. He renews his friendship with Daniel de Monfreid, whom he had met before at Emile Schuffenecker's house. The art critic Albert Aurier and the painter and writer Charles Morice give him their support, whilst the renowned poet Stéphane Mallarmé often invites him to his home. The Nabi group fete him as "the greatest symbolist painter." His plans are constantly talked about by other artists, and interest in "M. Gauguin's exotic plans" now spreads to the general public. The painter himself is hoping to find the money for the voyage to Tahiti by holding a large public auction of his works. Octave Mirbeau writes about it on 16 February 1891 in the *Echo de Paris:* "I hear that M. Paul Gauguin is intending to make a journey to Tahiti. He wants to live in seclusion there for several years, to build his own hut and to return with renewed vigor to all those ideas that occupy him so intensely. I find it both strange and moving to think of a man who wants to turn his back on civilization and who is expressly seeking out tranquillity and obscurity in order to hear all the more clearly his own inner voice, drowned out as it usually is by enervating passions and conflicts."[10]

The auction took place in the Hotel Droûot on 23 February and when the takings had been counted Gauguin was utterly overwhelmed. Of the thirty pictures that were up for auction, twenty-nine had been sold. The artist now had over ten thousand francs to his credit! He had not seen so much money since his days as a stockbroker. And he was particularly delighted that the famous painter Edgar Degas had bought his picture *La Belle Angèle* for four hundred and fifty francs. What

Stéphane Mallarmé
1891, Etching
7 $\frac{1}{8}$ x 5 $\frac{1}{2}$ in. (18 x 14 cm)
Bibliothèque d'Art et
d'Archéologie, Paris

Gauguin's daughter Aline in 1895, at the age of 18, two years before her early death

an honor and what recognition! He felt sure of success and was convinced that he was doing the right thing. And now he felt strong enough to go to Copenhagen to bid farewell to Mette and the children before his journey into the unknown. He arrived in Copenhagen on 7 March 1891. After six years without having seen him his children did not recognize him. But soon they were on the same good terms as before. His son Pola writes about this in his book: "But his daily intercourse with the two eldest brought back memories and loosened the tongues of all three, giving him an insight into their minds, where he found a tenderness he had so sorely missed and longed to be able to express in the life he had been leading. With them he could be what he was in his art; simply and naturally he could touch the chords of tenderness in living human children. They were his and he saw much of himself in them, especially in Aline, who bore a strong outward resemblance to him, and whose disposition oscillated between violent emotion and shy reserve. She was the one who felt most keenly the happiness of having her father with them, as she had missed him most and had also felt ashamed when asked who and where her father was, the father whose name was always mentioned with a certain awkwardness in the family circle.

"What a joy it was to these children when in the mild April weather they drove in an open carriage through the streets and people turned to look at the queer foreigner who sat back between his two children, Emile proud and cheerful in his school-boy's uniform, Aline stirred and happy! Many a tangled perplexity was smoothed out in Gauguin's mind in the three weeks during which he laid it open to his children."[11]

Despite all this, Mette remained very reserved towards her husband. She did not want to embark

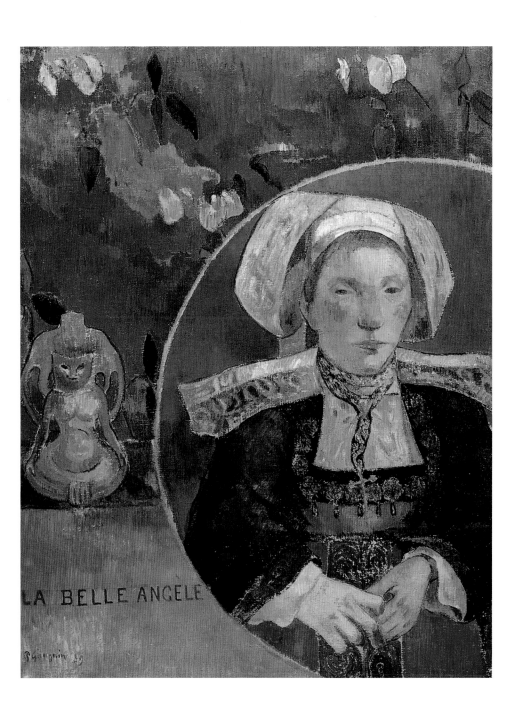

La Belle Angèle, 1889
36 ¹/₄ x 28 ³/₄ in. (92 x 73 cm)
Musée d'Orsay, Paris

on a new relationship with the man she had loved so much and who had so bitterly disappointed her. Shortly before her death she spoke about the past to her youngest son: "I could not understand his taking up art, but now I understand that he had a right to act as he did. But surely no one can be surprised that I refused to accompany him and bear him more children in an existence which to my mind was a mad and hopeless adventure."[12]

Back in Paris and Gauguin basks in friends' tributes to his success. In Café Voltaire at seven o'clock in the evening on 23 March Stéphane Mallarmé gives the address at a farewell banquet for Gaugin. About thirty of his closest friends are present and they are generous with their appreciation, praise, and advice. The Théâtre des Arts also puts on an evening event for Gauguin, and friends obtain an official mission of some sort for him from the Ministry of Culture, although neither he nor his biographers go into any detail anywhere on this matter.

Gauguin receives a reduction of thirty percent on the price of the voyage to the South Seas and hopes that the recommendation he has from the Ministry will set him off to a good start so far away in Tahiti. Full of enthusiasm and emotion he writes to his family in Copenhagen: "Farewell, dear Mette, dear children. Love me. And when I am back, we will get married again. Which means that today I am sending an engagement kiss to you."[13]

Paul Gauguin
Photograph by Boutet
de Monvel, c. 1891

Mette Gauguin, 1879
Marble
Courtauld Institute Galleries,
London

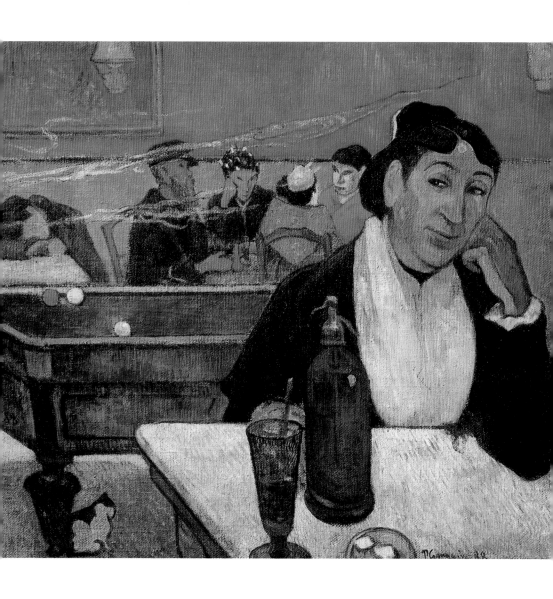

At the Café (Madame Ginoux)
1888
28 ³⁄₈ x 36 ¹⁄₄ in. (72 x 92 cm)
Pushkin Museum, Moscow

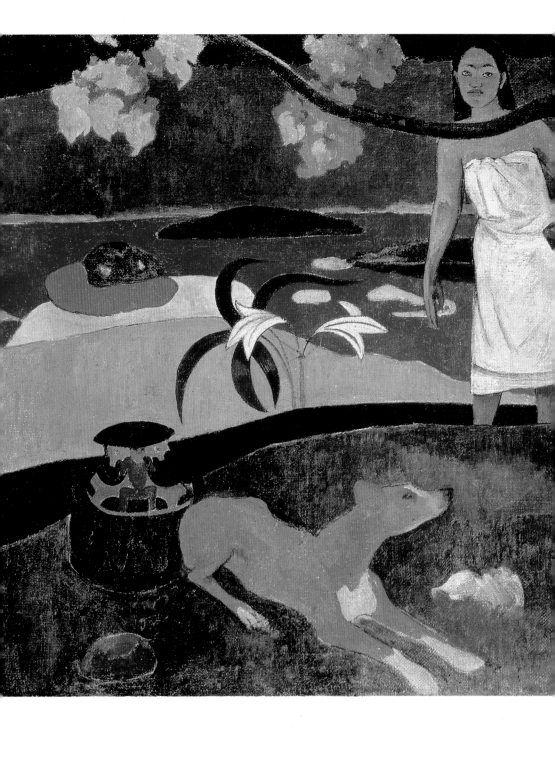

astorales Tahitiennes
1893
Paul Gauguin

The First Journey
1891–1893

Tahiti – The Scented Isle

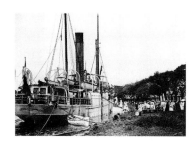

"I don't know why the Government have given me this assignment. Perhaps they wish to give the impression that they are supporting an artist . . ." Thus Gauguin begins his first notes for his book *Noa Noa*. "I have been traveling for thirty-six days now and I am burning to set foot on the land of my dreams. On 8 June we noticed strange lights gliding to and fro — fishermen. A jagged round form loomed up into the dark sky. We sailed round Morea and saw Tahiti there before us . . ."[14]

Copious notes for his book *Noa Noa* and a lively exchange of letters with friends and with Mette between June 1891 and July 1893 throw considerable light on Gauguin's life on Tahiti and on his state of mind, as long as it is not forgotten that documentary accuracy was not a matter that overly concerned him in his reports, nor were ethnographic or sociological descriptions. Rather, his sole intention was to convey to his friends and supporters in Paris a picture of paradise lost and regained, to give them an idea of his happiness in this paradisal form of primitive existence, and to tell them about the manner in which he was now realizing hallucinatory daydreams in his work as an artist.

Gauguin's first days in Papeete plunged him into a whirlpool of conflicting feelings and contradictory impressions: Governor Lacascade along with local civil servants and clerics received the painter from home, who was there in an official capacity, with all due honor — it was after all safe to assume that he was an emissary in disguise and had been sent by the Government to cast a critical eye over this particular colonial administration. Just for a moment the erstwhile stockbroker believed that he might manage to fit in with these people, or at

Pages 20/21 Tahitian Pastorales
1893
33 ⁷⁄₈ x 44 ½ (86 x 113 cm)
The Hermitage, St. Petersburg

The steamship *La Croix-du-Sud* in the harbor at Papeete

Paul Gauguin's house in Paea 1892

Both photographs are by Charles Spitz, the only professional photographer on Tahiti at the time.

The Little Black Pigs 1891
35 ¾ x 28 ⅜ in. (91 x 72 cm)
Museum of Art, Budapest

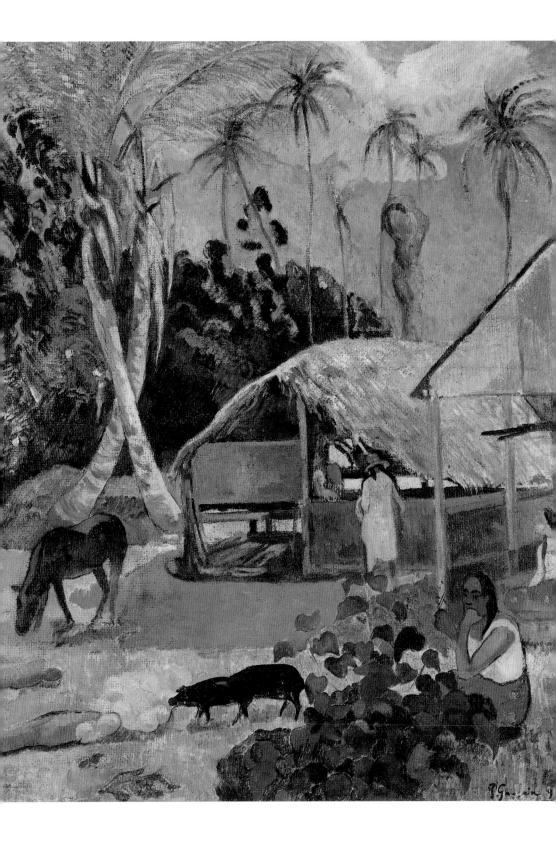

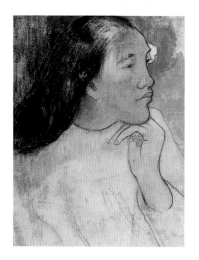

least to maintain a semblance of good manners towards them and at last, as an accepted member of the white elite, be able to paint in peace. But soon it became clear to him that he had not left behind all that was familiar and fled many thousands of miles across the sea from France to escape misunderstanding and rejection, that he had not endured bitter poverty and suffered so much and been such a burden to others only to be dictated to again by "European" notions here — virtually at the end of the world. So, just as he had always done in the past, he decided he must follow his own very individual interests as an artist, even if it meant rejecting the society he came from. As a consequence he abruptly left Papeete and built himself a hut in the district of Mataiea, which was some thirty miles away from the capital, on the south coast of the island.

Gauguin had now, for the first time, entirely withdrawn from European society and was living alone amongst the Tahitians, whom he called "Maoris." He showed he wanted to learn their language and to understand their habits and their customs. It seemed as though at last that most basic, "primitive" way of life that he had always dreamed about was opening up to him. He went on extended walks, drew, and painted, captured by the magic of this apparently unspoiled world. As he wrote in his diary: "I am feeling better every day; I can already understand the language quite well; my neighbors — three live close by, the other much further away — almost view me as one of them; walking daily barefoot on the stones means that my feet are now used to the ground; my body, which is naked more often that not, is no longer afraid of the sun; little by little, step by step, civilization is peeling away from me"[15]

Tahitian Woman, ca. 1892
Pastels on paper
15 ³⁄₈ x 11 ⁷⁄₈ in. (39 x 30.2 cm)
The Metropolitan Museum of Art, New York, Adelaide Miltonde Groot Bequest, 1967

Teha'amana Has Many Ancestors (Merahi Metua no Teha'amana), 1893
30 x 21 ¹⁄₄ in. (76.3 x 54.3 cm)
The Art Institute of Chicago

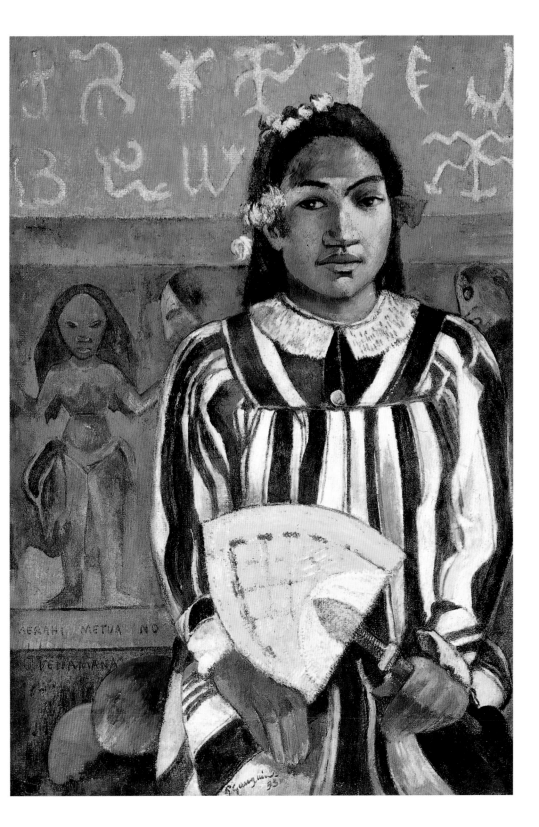

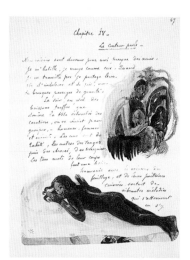

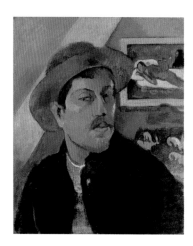

Gauguin also included motifs from his own works in his decorations for his manuscript *Noa Noa*. On page 67 he made a watercolor of Teha'amana reclining, as in his 1892 painting of her.

Self-Portrait , 1893
17 ³/₄ x 15 in. (45 x 38 cm)
Musée d'Orsay, Paris
In the background can be seen
The Spirit of the Dead Keeps Watch

On one of his walks a family hospitably invites Gauguin in. They eat and chat together until he is suddenly taken aback by an entirely unexpected occurrence: the daughter of the family — who must be all of thirteen years old and who goes by the name of Teha'amana (in *Noa Noa* Gauguin repeatedly refers to her simply as Tehura) — is offered to him in marriage. He likes the girl, he is lonely, and hence decides to take the young Teha'amana with him.

"We arrived in Taravao, I gave the gendarme his horse back. And his wife, a Frenchwoman, said to me (not unpleasantly by the way, but also not very kindly) 'So! I see you've brought a whore with you.' And with her angry eyes she undressed the young girl, who was calm but who was now also aware of her own worth. The wilting bloom stared at the new blossom, socially acceptable virtue breathed impure breath over the pure, natural shamelessness of innocent trust. And it struck me painfully to see this dirty smoke-cloud in such a clear sky. I was ashamed of my race and my eyes turned away from the swamp, which I then quickly forgot, and I gazed instead at the golden creature, whom I already loved — I can still remember it vividly."[16]

Gauguin wrote in detail about his life with the young Teha'amana: "I returned to my work and bliss followed upon bliss. Every day when the sun rose, shining light filled my home. The gold from Tehura's face shone all around and we often went together to refresh ourselves in a nearby stream, simply and naturally, just as though we were in Paradise.

"Our daily life — Tehura gives herself to me ever more fully, loving and quick to learn, I am quite filled with the Tahitian noa noa [in its correct spelling the Tahitian word *no'ano'a* means "scent"

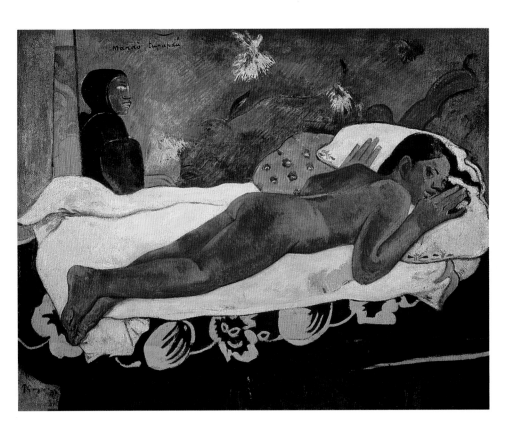

The Spirit of the Dead Keeps Watch
(Manaó tupapau), 1892
28 ¾ x 36 ¼ in. (73 x 92 cm)
Albright Knox Art Gallery,
Buffalo, New York

or "sweet-smelling, scented"]. I myself am losing any sense of days and hours, of good and bad — everything is beautiful, everything is good. She is instinctively silent when I am working, when I am dreaming she always knows when she can speak to me without disturbing me.

"Conversations about life in Europe, about God, about the gods — I teach her, she teaches me. . . ."[17]

It is only too tempting to go along with this picture of events, to credit Gauguin's actions with real spontaneity, and to take his almost childlike descriptions at face value — if only it were not for the book *Le Mariage de Loti*, brought out in 1880, under the name of Pierre Loti, by Julien Viaud, an officer in the Marines who was at the same time a

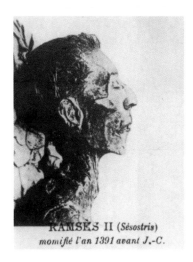

RAMSÈS II (*Sésostris*)
momifié l'an 1391 avant J.-C.

Pierre LOTI
non momifié encore
à la fin du XIX° siècle de notre ère

The travel writer Pierre Loti, whom Gauguin greatly admired and who had himself photographed in the same pose as the mummified Ramses II

The Name is Vairaumati
(Vairaumati tei oa), 1892
35 ³/₄ x 23 ³/₄ in. (91 x 68 cm)
Pushkin Museum, Moscow

travel-writer and an amateur painter. It describes in a rapturously romantic manner how as a young sailor on Tahiti he was given the name Loti and took a thirteen-year-old girl as his companion and lover.

When he was still in France Gauguin had often dreamed of the travels of Loti, who in true colonial fashion had, as a sea cadet, already written to his sister: "When I am at last a mariner, I will be able to possess all those things that I have dreamt of for so long . . ."[18] Gauguin on the other hand nursed the suspicion that his circumstances would never allow him to embark on any such wonderful adventures. In 1890 he wrote in a letter to Emile Bernard: "Loti saw that from the point of view of a literary man, he had the ship at his disposal and was wealthy to boot . . ."[19]

Gauguin's description of Teha'amana would seem to owe at least something to Loti, or at the very least to have been improved in that direction. It is certain that, as was the custom on Tahiti in those days, Teha'amana's parents did allow the girl to go "temporarily" to Gauguin in exchange for gifts. She did not come to him by some happy chance. Gaugin took her for himself because the "brown Eve" whom he had often mentioned had not so far appeared in his dream paradise. And in this there is already the suggestion that for all his respect for "primitive peoples" he was not entirely able to shed those notions that he still owed to fin-de-siècle Europe.

Apart from this it is clear from his writings that he exercised a form of self-censorship on all that he either wrote or painted — with an eye to his real addressees, who were in fact the main focus of his energies: his hoped-for public in Paris. His texts always have a didactic function intended to further public understanding of his work as an artist. In

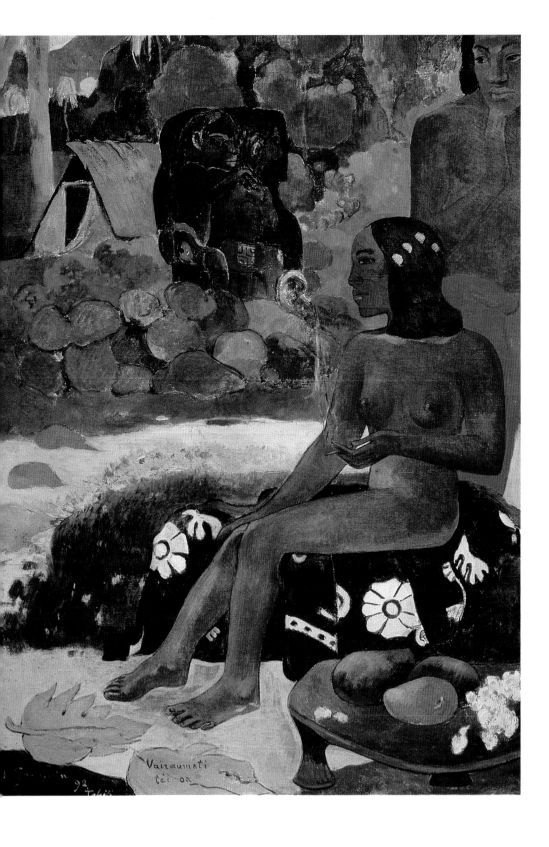

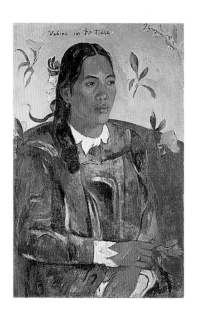

letters to other artist friends, however, he often expressed the fear that he was not able to break through the lack of comprehension with which official critics had so far regarded his work. So in 1892 he wrote to Paul Sérusier: "My head is in flames, but none of the things that inspire me can frighten me. For if my early works were rejected by the *Salon*, what will they say about my new ones?"[20]

The Woman with the Flower
(Vahine no te Tiare), 1891
27 ⁵/₈ x 18 ¹/₈ in. (70 x 46 cm)
Ny Carlsberg Glyptotek, Copenhagen

Tahitian Women on the Beach, 1891
35 ⁷/₈ x 20 ⁷/₈ in. (91 x 53 cm)
Academy of Arts, Honolulu

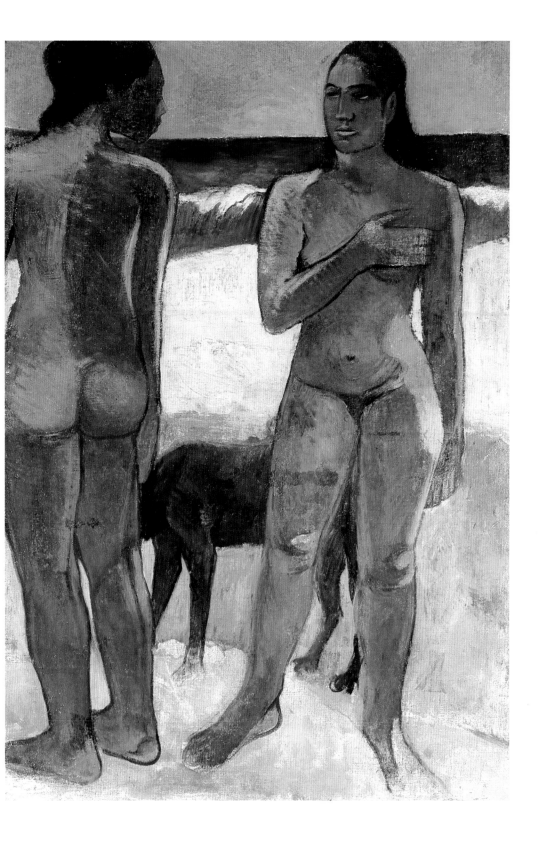

Pastorales Tahitiennes

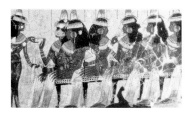

Although there is clear evidence that Gauguin often raised the cause of the Tahitians and their rights with the French administration, he nevertheless maintained a certain distance from them. He saw himself as a gentleman and wanted to be recognized as such: not by his Tahitian neighbors but certainly by the French elite — he had after all once virtually been one of them himself. In fact his rebellion, his self-imposed status as an outsider, and the role he had created for himself as *artiste maudit* were all expressly designed to enhance his reputation as an artist. For, as Matisse wrote: "he had gone there as a troublemaker" and only "his injured pride kept him going."[21]

That is not to say that Gauguin was not moved by the Tahitian landscape nor that the life there did not influence his work. That was undoubtedly the case, and without his "flight" his pictures would not have taken the form they did. But right from the outset he was deluding himself in imagining that, having left civilization behind him, he could "invent" a completely new kind of art that would shatter the artistic traditions of Europe. Shortly before he set out on his journey he was to write to Odilon Redon: "I am taking photographs and drawings with me, a whole little world of friends that will talk to me each day about you."[22]

So it is hardly surprising that Gauguin's work should contain a large variety of conscious or even unconscious adaptations taken from many different sources. In 1892 he painted *The Market.* The poses of the women could easily be found in ancient Egyptian paintings and reliefs. The row of figures is shown strictly in profile, with the upper body turned towards the viewer and the heads either in full profile or facing the viewer. Other angles,

Ancient Egyptian tomb painting from Thebes ca. 1500–1400 B.C. British Museum, London

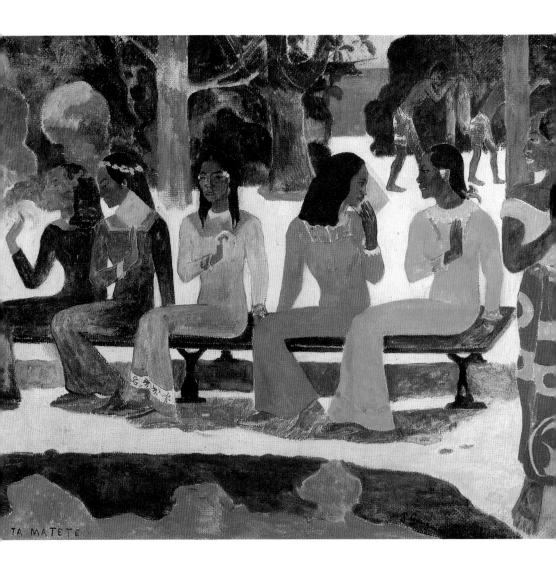

The Market (Ta Matete), 1892
28 ¾ x 36 ¼ in. (73 x 92 cm)
Kunstmuseum Basel

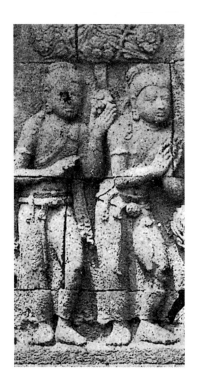

perspectival foreshortening, and similar devices are avoided, underlining the fact that these figures represent character types, and any element of chance is kept at bay.

Gauguin, who was sporadically interested in Buddhist teachings, must have been familiar with photographs or drawings of the Javanese Temple of Borobudur. In *Ia Orana Maria*, which he completed shortly after his arrival on Tahiti, he has fully assimilated the formal language of Ancient Java into his own visual world. The two female figures shown approaching Maria and the Christ Child in reverence are startlingly similar to two figures on a relief in the Temple. There is such a close resemblance in the perspective, the bodily posture, and the way one figure is walking behind the other that this could not be due to coincidence alone.[23]

Gauguin was clearly a well-read man and repeatedly protested against the glorification of the art of antiquity, whose traditions nineteenth-century academics had consciously adopted. Yet despite this he, too, cites from classical Greek art, as can be readily seen if one compares his *Man with the Ax* (1891) with the Parthenon frieze. Indeed, he was more than once to take up motifs and figures from the work of his contemporaries, although he, of course, cast these in his own individual and original mode of expression. Gustave Courbet's *La Source* is for example instantly recognizable in Gauguin's *Tahitian Women on the Beach* of 1892.

Gauguin used the art of the past and of his own present as a source of inspiration with the same ease as he sometimes used photography. Evidence of this, too, has come down to us, in for example the photograph of a Tahitian drinking from a well taken by Charles Spitz, the only professional photographer living on Tahiti at the

Figures from the relief in the Temple of Borobudur in Java

Hail Mary (Ia Orana Maria), 1891
44 ⁷⁄₈ x 34 ⁵⁄₈ in. (114 x 88 cm)
The Metropolitan Museum of Art, New York, Sam A. Lewisohn Bequest, 1951

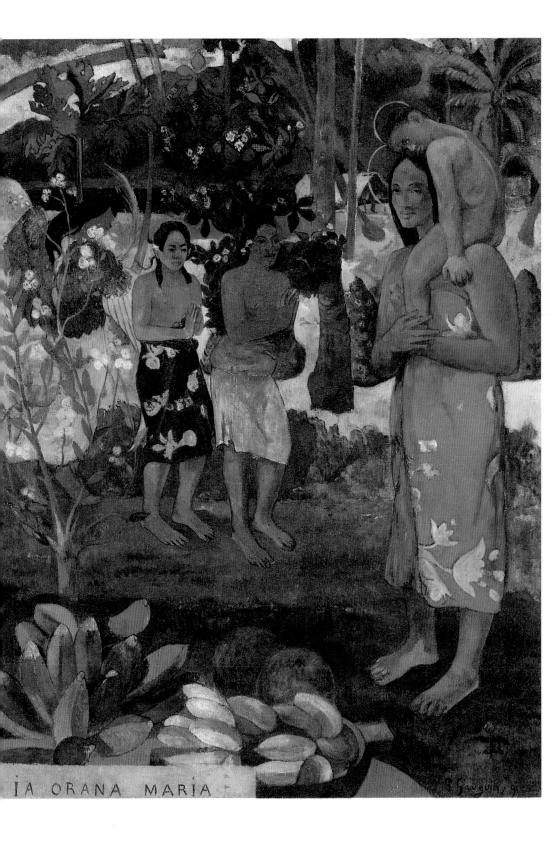

IA ORANA MARIA

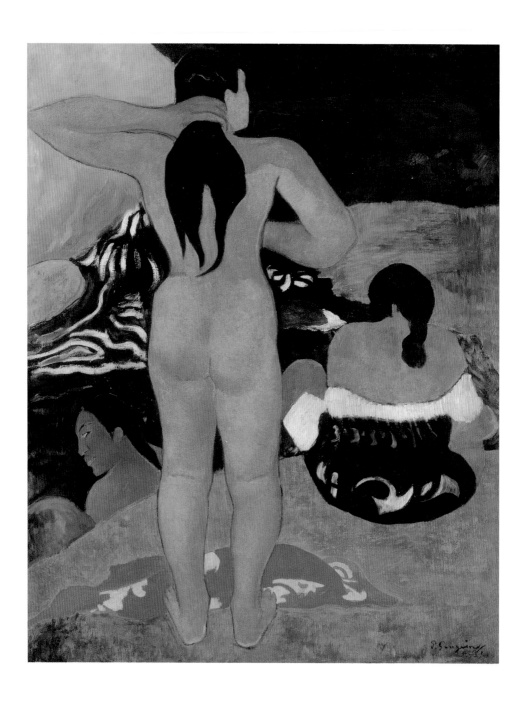

Tahitian Women on the Beach, 1892
44 ⅛ x 35 in. (112 x 89 cm)
The Metropolitan Museum of Art,
New York

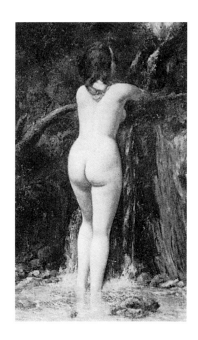

time. Gauguin liked the pose of the youth drinking so much that he used it as the basis for his *Mysterious Water*.[24]

Like any other artist Gauguin carried his very own "imaginary museum" around in his head, using it for his own iconography. What matters is that he applied his own creative will to these visual reserves and memories in such a way that he succeeded in integrating them into his own personal style — a style that was both clearly defined and finely differentiated at one and the same time. He himself recognized this and wrote with some confidence in a letter to Sérusier: "My art is centered in my mind and nowhere else. I am strong because I let nothing put me off and also because I follow what is within me. Beethoven was deaf, completely cut off; which means that his works are imbued with the greatness of an artist who lives on his own, particular planet."[25]

During this time Gauguin painted Teha'amana frequently, and portraits of her are amongst the best he produced during those early years in the South Seas. But this period, whilst being carefree and productive, was not to last long. In the spring of 1892 Gauguin suffered a severe heart attack and had to go into hospital. He wrote to his wife in Copenhagen: "I am spitting blood — a small bucket's worth . . . and my hospital treatment is costing me twelve francs a day. You know me. I don't want to stay here in such a depressing situation."[26]

These lines touch on another anxiety which was a growing concern to him. He had used up all his financial reserves and there was little hope of any money coming from Europe, even though his friends had promised to support him. The poet Charles Morice still owed him money and some pictures which had been sold had not yet been paid for. Mette had made a considerable amount from

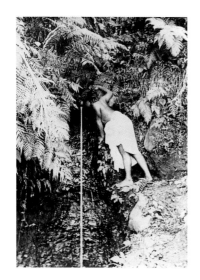

Gauguin also used photographs as the basis for some paintings. This photograph is by Charles Spitz.

Mysterious Water (Pape moe), 1893
39 x 29 ½ in. (99 x 75 cm)
Private Collection, Switzerland

a major exhibition of his works in Copenhagen — including nine sent from Tahiti. But out of sheer resentment she was not prepared to help her husband. Mette saw the money as her own by rights, and was determined that it be used to guarantee some sort of security for her children as they were growing up.

As Gauguin was now no longer able to paint, he was without the financial resources to cover even his most basic needs. Hunger, so painfully familiar, made its return. In addition there was bad news from home, for he learnt of the death of Théo van Gogh in a mental health institution. Vincent van Gogh's brother, in his position with the Paris dealers Goupil, had always promoted Gauguin's work and had just managed to sell a whole string of his pictures.

On top of this the young art critic Albert Aurier had died of tuberculosis. Early in 1893 Gauguin made a note: "First Théo at Goupil's, then Aurier, the one critic who understood us properly and who could have helped us a great deal in the future."[27]

Gauguin decided to go back to Paris in order to straighten out his affairs in person. Apart from this he was filled with the hope that now, two years after his success in the Hôtel Drouot and with his sixty-six pictures done on Tahiti, he might at last achieve recognition as an artist worth his salt. In the end it was his generous friend Daniel de Monfreid who provided the funds for the journey.

Teha'amana, who was expecting a child, stayed behind alone on the "scented isle." Once again Gauguin was to cause suffering to someone who had done so much for him. When it came to his painting and his success as an artist he completely ignored any moral obligations or emotional attachments, treating even those closest to him with scarcely credible harshness and coldness. Mette was

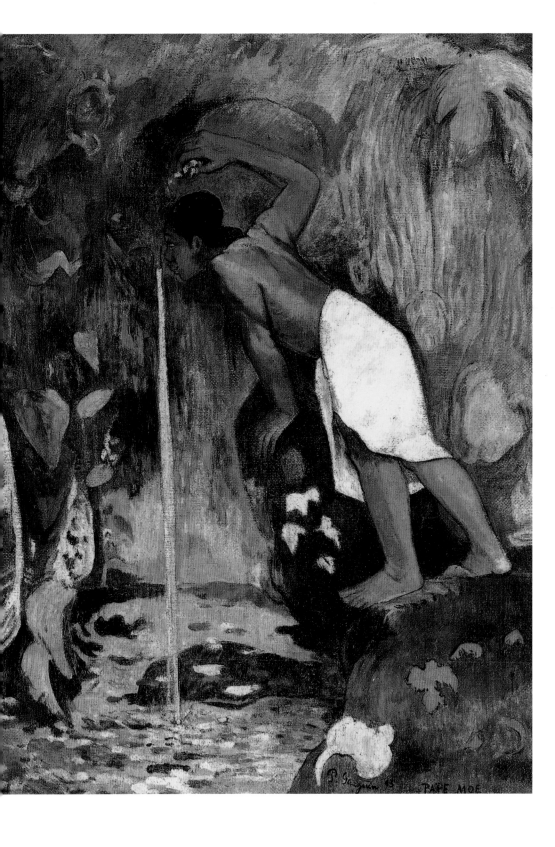

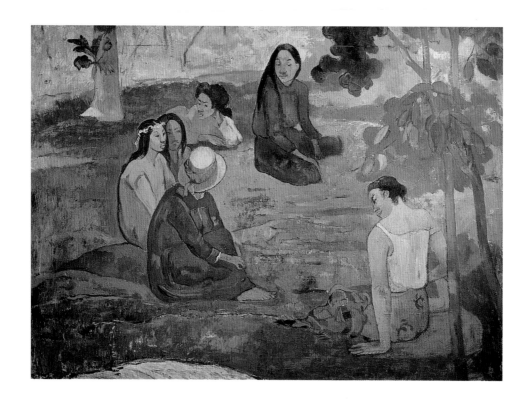

never able to forgive him for leaving her and their children. In Arles he had abandoned Vincent van Gogh without the slightest consideration for the latter's state of health when he saw that their work together as artists could go no further. He similarly showed no scruples in leaving Laval behind on Martinique, sick though he was. At times he would refer disparagingly to his painting friend Schuffenecker as mundane and petit-bourgeois, although this former colleague of his from Bertin's Bank had so often come to his help. And on top of all this in 1891, when he left Paris for the South Seas, he had left behind him his lover, Juliette Huet, despite the fact that she was expecting his child.

Now, on 30 August 1893, Gauguin is back on French soil, in the port of Marseilles. Once again he is alone, once again he has nothing other than his pictures, this time the results of his time in the South Seas. But he does now also have a thirty-

Conversation, 1891
28 ¾ x 36 ¼ in. (73 x 92 cm)
The Hermitage, St. Petersburg

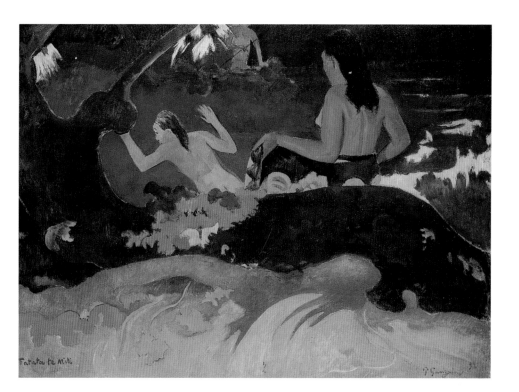

eight-page manuscript with the title *Noa Noa*, describing his experiences on Tahiti and some of the pictures that he had completed there.

The Sea is Near (Fatete te Miti), 1892
23 ³/₄ x 36 ¹/₄ in. (68 x 92 cm)
National Gallery of Art, Washington,
D.C., Chester Dale Collection

Women at the River (Auti te pape), 1894
Woodcut

Noa Noa
Woodcut of the head of the sleeper in
The Spirit of the Dead Keeps Watch

pages 43–47:
Noa Noa
This unique artist's book is
characterized by the harmony of its
text and illustrations.

Shortly after his arrival in Papeete, Gauguin began to make notes about his experiences and impressions. At first this was merely a matter of keeping a personal diary but soon he was toying with the idea of publication. There were two main reasons for this. On the one hand, he hoped that his Tahitian tales might be as successful as Julien Viaud's South Seas novel *Le Mariage de Loti*, written a few years previously. On the other hand, he viewed his writings as a form of commentary on his own paintings, which should make his work more accessible to the public. He wrote to Mette in 1893: "In addition I am working on a book about Tahiti, which will be very useful in helping people understand my paintings."[28]

Not convinced of his own literary abilities, when he was back from Tahiti Gauguin turned to Charles Morice, asking him to go over the manuscript and prepare it for publication. Morice was fully aware that he was in Gauguin's debt, for he had after all not passed on to him fifteen hundred francs from the art dealer Goupil as agreed. Gauguin had been waiting somewhat desperately for this money on Tahiti, as can be seen in a letter written in May 1892 to his friend Daniel de Monfreid: "And this is all Morice's fault. He hasn't written to me once since my departure. He has money for me and has not sent it."[29]

Now in the autumn of 1893 their work together was intended to consolidate their recent reconciliation. Gauguin therefore entrusted Morice with the thirty-eight handwritten pages, to which he had given the title *Noa Noa*, as well as another manuscript entitled *Ancien culte mahorie*. In fact this manuscript consists in the main of résumés and

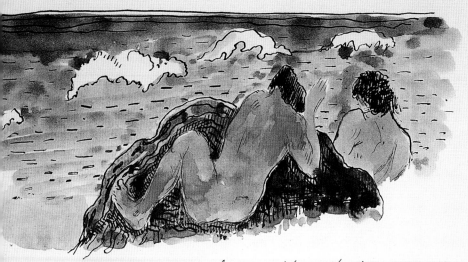

d'elle en lui, par lui se dégageait, émanait un
parfum de beauté qui enivrait mon âme, et où
se mêlait comme une forte essence le sentiment
de l'amitié produite entre nous par l'attraction
mutuelle du simple et du composé.

Était-ce un homme qui marchait là
devant moi ? – Chez ces peuplades nues, comme
chez les animaux, la différence entre les sexes est bien
moins évidente que dans nos climats. Nous accentuons
la faiblesse de la femme en lui épargnant les fatigues
c'est-à-dire les occasions de développement, et nous la
modelons d'après un menteur idéal de gracilité.
À Tahiti, l'air de la forêt ou de la mer fortifie
tous les poumons, élargit toutes les épaules toutes
les hanches, et les graviers de la plage ainsi que les
rayons du soleil n'épargnent pas plus les femmes
que les hommes. Elles font les mêmes travaux

heurtant au tronc rugueux des cocotiers. — La
première chanteuse commence : comme un oiseau
altier elle s'élève subitement aux âmes de
la flamme. Son cri puissant s'abaisse et
remonte, planant comme l'oiseau, tandisque
les autres volent autour de l'étoile en satellites
fidèles. Puis, tous les hommes, par un cri barbare,
un seul terminent en accord dans la tonique.
Ce sont les chants tahitiens, les _iménés_

Ou bien, pour chanter et causer on
s'assemble dans une sorte de case commune.
On commence par une prière, un vieillard
la récite d'abord, consciencieusement et toute
l'assistance la reprend en refrain ! Puis on
chante. D'autrefois fois on conte des histoires
pour rire. Plus rarement on disserte sur
des questions sérieuses, on fait des propositions
sages.

Voici celle que j'entendis un soir et
qui ne laissa pas de me surprendre :

« Dans notre village, disait un vieillard
on voit depuis quelque temps par ci par là
des maisons qui tombent en ruine, des toits
pourris, entr'ouverts, où l'eau pénètre quand

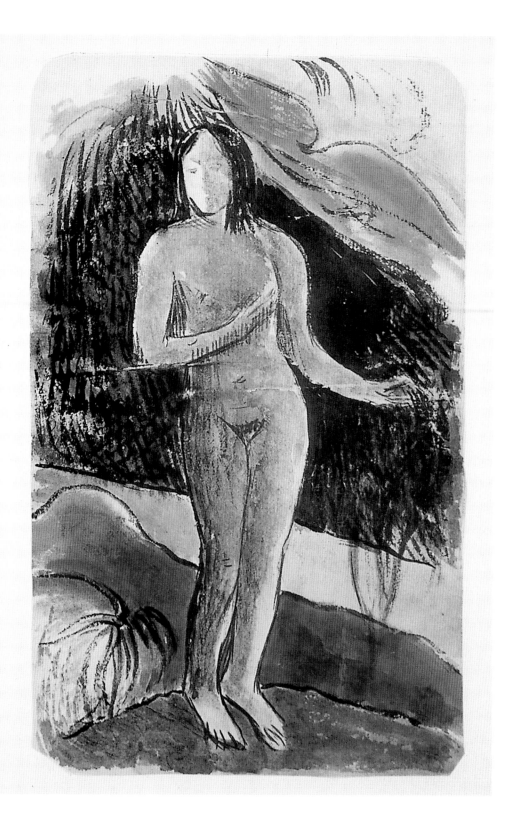

Il arriva que j'eus besoin, pour mes projets
de sculpture, d'un arbre de bois de rose; j'en
voulais un fût plein et large. Je consultai
Jotépha. —

Il faut aller dans la montagne, me dit-il.
Je connais, à un certain endroit, plusieurs
beaux arbres. Si tu veux, je te conduirai,
nous abattrons l'arbre qui te plaira et
nous le rapporterons tous deux.

Nous partîmes de bon matin.
Les sentiers indiens sont à Tahiti assez
difficiles pour un Européen. Entre deux
montagnes qu'on ne saurait gravir deux
hautes murailles de basalte, se creuse une
fissure où l'eau serpente à travers des
rochers qu'elle détache, un jour que le
ruisseau s'est fait torrent et qu'elle entrepose
un peu plus loin pour les y reprendre un peu plus
tard et finalement les pousser, les rouler
jusqu'à la mer.

De chaque côté de ce ruisseau fréquemment
accidenté de véritables cascades, un semblant
de chemin parmi des arbres pêle-mêle; arbres
à pain, arbres de fer, pandanus, bouraos,
cocotiers, fougères monstrueuses, toute une

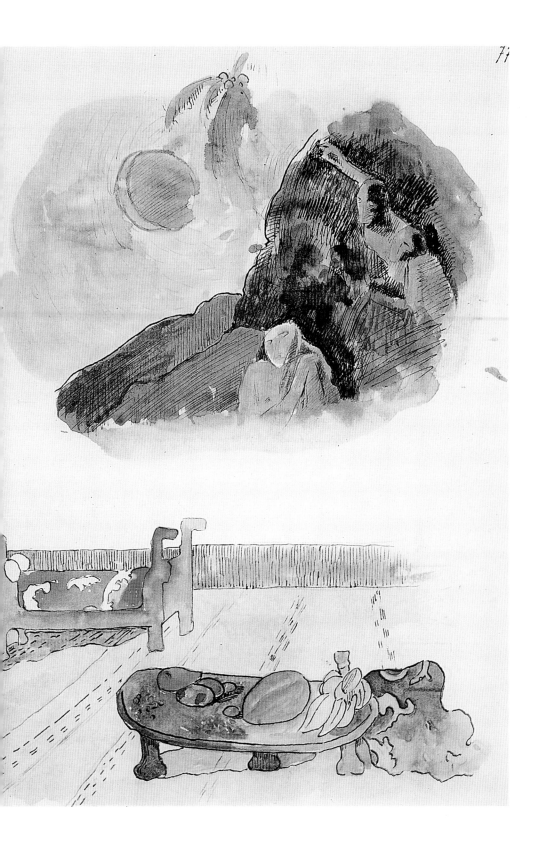

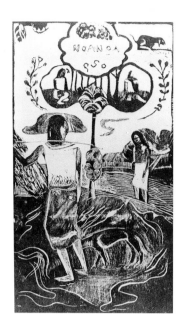

Noa Noa
Title woodcut for the planned
publication 1894

excerpts from the writings of J.-A. Moerenhout, a Belgian who had spent several years in Oceania and had researched ancient religious beliefs. Gauguin added some thoughts of his own to this text and illustrated the manuscript with some fine watercolors.

Morice was keen to edit Gauguin's *Noa Noa* manuscript and to add in some Symbolist poetry and prose of his own. Gauguin was taken by this idea, above all because his intention in his stories from Polynesia was to contrast the character of an "uncivilized" people with that of the Europeans and so he "felt it would be very original simply to write as a savage alongside a sophisticate like Morice."[30]

Gauguin also planned to further enhance the book with a series of woodcuts. Ten prints were ready by the spring of 1894 and together with the printer Louis Roy he attempted to prepare the blocks for printing, but since he was not satisfied with the results he decided to use colored monotypes instead.

But all these plans fell through when Morice's revised text was delivered, for, far from meeting with Gauguin's approval, it filled him with a kind of horror. Morice had not only added in texts of his own but he had changed Gauguin's texts to such an extent that the painter's intended contrast between "primitive" and "civilized" language had been completely lost and he felt as though the whole thing had been taken out of his hands in a wholly unacceptable way. Gauguin was now far more confident about his own literary abilities. He dropped the notion of publication, but did make a copy in his own hand of the text edited by Morice. When he again set out for the South Seas in 1895 he took this manuscript with him. He now cut and edited Morice's chapters and

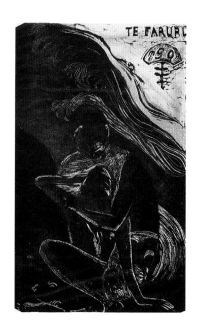

added a foreword as well as another chapter of his own. He then copied the whole thing once again and decorated the manuscript with drawings, woodcuts, watercolors, monotypes, and photographs.

This then was how one of the earliest, most important and most beautiful artist's books of Modernity came into being — setting a standard which has endured to this very day. Since then many artists, including Marc Chagall, Georges Braque, and Anselm Kiefer, have also produced one-off artist's books.

As he began copying and illustrating his *Noa Noa* Gauguin had various aims in mind. Firstly, by making a fair copy he wanted to produce his own approved final version of the text, which would certainly seem to make sense in view of the volatile, frequently disappointing history of the plans for the book so far. Secondly, he wanted to gain as much control as possible over artistic aspects of any future published edition. But this was only to be achieved in his self-imposed isolation if he wrote and illustrated the entire book in exactly the form he would wish it to be when published. For *Noa Noa* had by now already become a part of his own history and — however unrealistic it might be to think of its being published in the foreseeable future — it mattered a great deal to him to use a whole variety of artistic means to maximize its value and to lend it the status of an original art work in its own right. So he carefully laid down the format, defining the margins as in any printed book and inserting page numbers in the upper right- hand corner. His elegant hand, the result of calligraphic training during his years in banking, gave the pages a blithe, spirited air. Woodcuts and other illustrations were carefully pasted in while he painted most of the watercolors directly on to the page, so that both harmony and

Noa Noa
Te faruru
Woodcut for the planned
publication, 1894

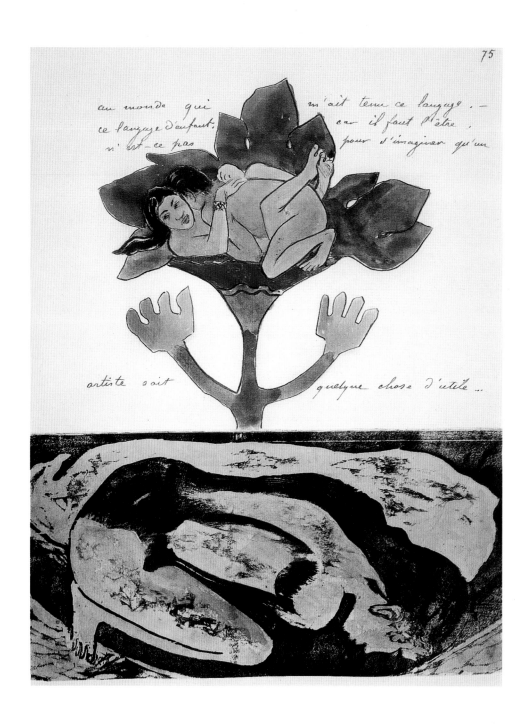

Noa Noa
Page 75 of the artist's book shows
Gauguin's collage technique; the
watercolor is painted directly on the
page and the woodcut is pasted in.

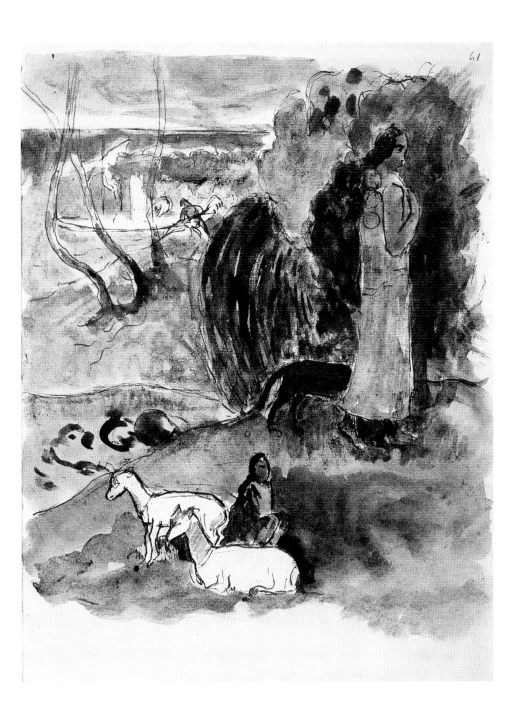

Noa Noa
Watercolor on page 61 of the
artist's book

tension were created in the juxtaposition of text and painting. Sometimes a page of text is faced by a full-page illustration (Page 44 ff.) and sometimes text encircles the illustration, which can lead to a lively, often captivating dynamic between text and illustration (Page 43).

Some motifs from the *Noa Noa* illustrations reappear in later oil paintings (cf. pp. 35, 62). But Gauguin also drew on motifs from earlier works, for example including in his book an illustration of his *Ia Orana Maria*, cut out of a newspaper and colored with watercolors. In this tour de force of his, Gauguin convincingly creates a beautiful, innocent, carefree world. And in his paintings this was the world he repeatedly sought to contrast with the corrupt, spoilt, bourgeois, ultimately inhuman conditions that prevailed in France.

Gauguin's text is fascinating above all for its spontaneous, direct language and the (apparent) authenticity of its descriptions. It is as though the reader is able to share Gauguin's years on Tahiti "at first hand." And in his or her mind's eye the reader can see that paradisal world which still presents itself to many Europeans today at the very mention of the expression "South Seas."

Yet Gauguin's narrative is often quite at variance with his actual experiences: he uses "collage" and alters events in order to create a poetic match for his pictures, which Octave Mirbeau had already described in 1891 as "a disturbing mixture of barbaric splendor, Catholic liturgy, Hindu dreaminess, gothic imagery, and dark, subtle symbolism."[31]

In the winter of 1895 the work of copying and illustrating was finished; the annex "Diverses Choses," which is made up of a varied collection of essays, was not put together until 1896/97. The book is bound in Danish linen and emblazoned with the title *Noa Noa* in red. The manuscript of

Noa Noa
Scout with grapes
Woodcut (detail)
This motif — used by Gauguin to symbolize the richness and fertility of the tropics — derives from medieval Christian iconograpy: Israel's scouts returning richly laden from Egypt.

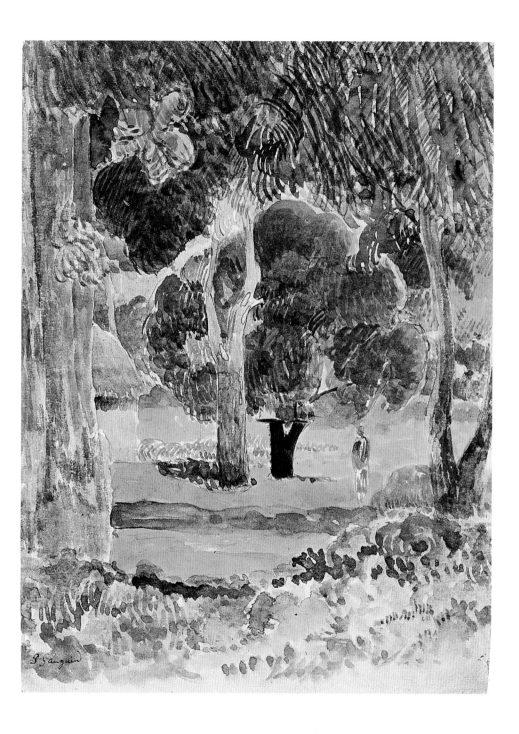

Noa Noa
Tahitian landscape
Watercolor

204 pages is divided into twelve chapters and contains ten woodcuts, two drawings, thirty-one watercolors, two monotypes, and seven photographs. As well as this there is an appendix which Gauguin illustrated almost exclusively with Japanese woodcuts.

After Gauguin's death the book became the property of Daniel de Monfreid, who in 1923 bequeathed it to the Louvre, where it is still to be found. Nowadays hundreds of thousands of copies of this version of *Noa Noa* are to be found in countless editions and has been translated into almost all European languages. Until well into the fifties it was taken to be Gauguin's own original text. An early German translation, by Luise Wolf and Herbert Eulenberg, was published by Paul Cassirer in 1925 as a text only version. In 1926 an extremely exact and attractive facsimile was published by Piper of Munich in a limited edition of 320 copies.

The original manuscript, those first thirty-eight pages that Gauguin had entrusted to Morice in 1893, had been lost. In 1908 Morice, constantly at prey to financial worry, had sold the manuscript to the Parisian bookseller Edmond Sagot, in whose attic it was eventually found in 1951.[32] Since 1984 it has belonged to the Getty Center for the History of Art and The Humanities in Santa Monica, California.[33]

Noa Noa
Tahitian women
Drawing colored with watercolors

Intermezzo:
France 1893-1895

A Herald of New Art

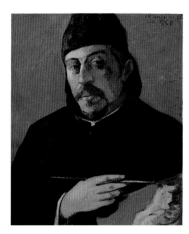

Self-Portrait with Palette, c. 1894
36 ¹/₄ x 28 ³/₄ in. (92 x 73 cm)
Private Collection, New York

Paul Gauguin
Photograph by Harlingue-Viollet

Back to Gauguin's arrival in Marseilles. It takes some days before he is able to raise the money for the onward journey to Paris. As so often before, he is forced to borrow money. This time Daniel de Monfreid and Paul Sérusier come to his rescue. He also borrows the money to rent and equip a modest studio in the rue de la Grande-Chaumière. But even despite his illness and a feeling of physical weakness, he remains undaunted in his hope that the Tahiti pictures will be a success. The long sea journey in overcrowded vessels has robbed him of much of his strength. "In Noumea I had to wait twenty days for the steamer and at my own expense too. (That was what the journey home was like for anyone without money.) That was hard. In the end I left on one of the liners which are so luxurious in first and second class. I traveled third class, penned in with a troop of two hundred soldiers. In order to be able to move each man was allotted fifty square centimeters on the foredeck in between the sheep and beef tethered there. And that's how it was for forty days. God, it's a long time. If it weren't for the sea one would much rather walk."[34]

A few months after returning to Paris his uncle, Isidore Gauguin, died in Orléans and the painter was hopeful that he might inherit a considerable amount. Through Edgar Degas, already famous in his own lifetime and much admired by Gauguin, there was a meeting with the well-known art dealer Henri Durand-Ruel, who declared his willingness to put the Tahiti pictures on show in his gallery. Gauguin threw himself into preparations for this and had a small catalogue printed with a foreword

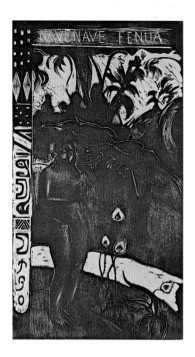

Gauguin made the woodcut
Nave nave fenua in 1894 in Paris.

Black lizard
(detail from *Delightful Land*)

by Morice. The show opened on 4 November 1893, with forty-six pictures up for sale. Artist friends — Mallarmé, Bonnard, Degas and the Nabis — were enthusiastic, but the general public was either baffled or simply amused. Crowds poured into the exhibition as though it were a fair and laughed at his "naked Eve" *(Te nave nave fenua)* and dubbed her the "monkey woman." Yet this work is an outstanding synthesis of Western iconography, with its emphasis on planes of strong color in the style that Gauguin had developed in Polynesia. There can be no doubt that it is Teha'amana who is portrayed here as Eve in Paradise, in the "hortus deliciarum" — that pleasure garden as described in an illuminated manuscript of the same name from twelfth-century Alsace, which has served as the model for thousands of similar images in Western art, even to the extent of lending them its original title.

In Gauguin's treatment of the theme, however, instead of there being a snake above Teha'amana's right shoulder, there is a black lizard in the tree of knowledge, and the Polynesian Eve is not picking an apple but some fantasy flower, which most closely resembles a peacock feather.

The calm form of the almost statuesque figure nearly fills the entire right-hand side of the picture and dominates the composition. Strongly colored forms made up of small individual parts surround the figure in ornamental richness and splendor. But Gauguin does not merely create an image that is both decorative and suggestive; he also manages to reclaim for painting that very literary element the Impressionists had banned. Without once resorting to the chance anecdotal, Gauguin "recounted" his views and his own stories entirely by means of the visual language he himself had developed, conveying his aspirations, his ideas, and ultimately his

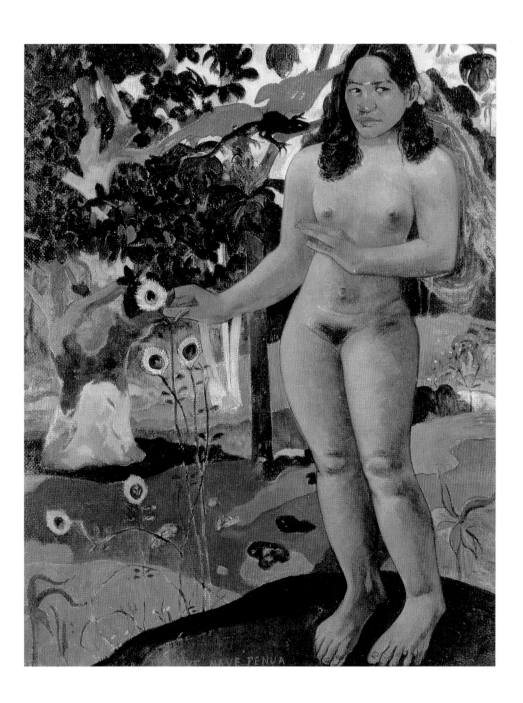

Delightful Land
(Te nave nave fenua), 1892
35 ³⁄₄ x 28 ³⁄₈ in. (91 x 72 cm)
Ohara Museum of Art,
Kurashiki, Japan

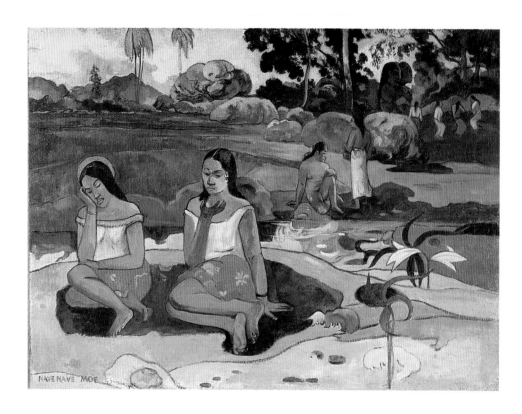

The Joy of Rest (Nave nave moe), 1894
28 ¾ x 38 ⅝ in. (73 x 98 cm)
The Hermitage, St. Petersburg

view of the world itself: his longing for reconciliation between civilization and Nature, between the cultured and the "primitive." In his pictures he wanted to create a world of his own, more beautiful, more honest, and purer than the one he knew. But as far as form was concerned he could not achieve this without some reference to European iconography. He needed it to make it clear to people that the bourgeois society in which they lived had become distorted and to contrast with this the paradisal ideal of a free, natural existence as he had come to know it on Tahiti. Nowadays it is only too clear that Gauguin did not in fact manage to become truly "primitive" or to do any significant damage to the existing canon of forms in the subsequent manner of the German Expressionists or, above all, of Picasso and Braque.

The Dresden Brücke artists had only experienced

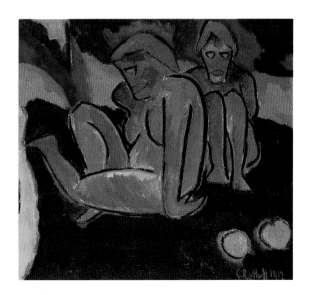

African native art in museums and yet this was enough to trigger an astonishing break with tradition. Gauguin, who lived amongst "savages" for many years, never destroyed notions of form as such, simply depicting again and again his delusions of paradise as it once was and using classical means to do so. And yet his pictures were perceived at the time as a form of provocation. The absence of perspectival correctness, the presence of heightened colors, black outlines, and in the end the "indecent" style of representation were unacceptable to critics and public alike. His message was not heard. Triumphant success eluded him.

Bitterly disappointed, Gauguin turned his back on his bourgeois public, filled with scorn for those people whose favor mattered so much to him and who were obviously quite unable to understand him. He had abandoned the idea of enthusing the public with his art. The most he would now hope for would be to shock them.

Gauguin's inheritance from his uncle Isidore — a by no means paltry thirteen thousand francs — had enabled him to rent a larger studio in the rue

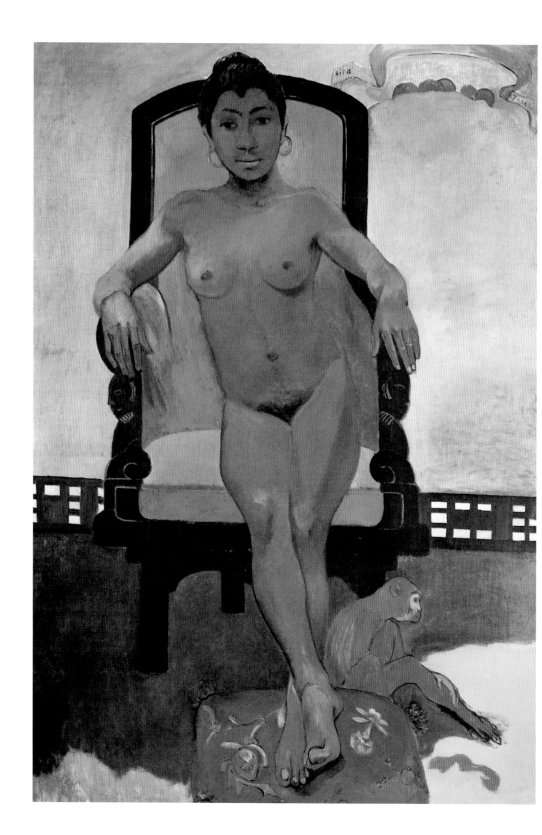

Vercingétorix and now the only people he saw were his artist friends. The door to his home was adorned with the words "Te faruru" (Love is honored here) and almost every Thursday he welcomed his extravagantly clad artist friends for an evening of good talk and good company. The decor in the studio was unusual, with weapons, shells, Polynesian carvings, Japanese woodcuts on the walls, paintings, and works by friends — including some sunflower pictures by van Gogh. The art historian Wilhelm Uhde describes how Gauguin himself would "appear in a long blue frock coat, with mother-of-pearl buttons, wearing a gray felt hat with a sky-blue band around it and in one of his large, white-gloved hands carrying a stick decorated with barbaric carvings and one pearl. . . . He lived with a Javanese woman in a studio filled with exotic objects in a house – which now no longer exists – near Montparnasse. We too, when we were young, lived for long enough in that same utterly miserable house in that dark, narrow street to have an idea of what grotesque discord there must have been in the combination of its petit-bourgeois inhabitants with Gauguin's bohemian theatricality."[35]

Gauguin was now living what many ordinary people might imagine an artist's life to be. A mulatto girl, "Annah the Javanese," lived with him as his lover. He painted her naked in a blue armchair, at her feet a monkey that shared their life in the studio. The picture — a masterpiece of intense color — shocked the public. Gauguin was glad.

He was hardly painting at all, frittering away the days, talking and living it up with friends, and yet unhappy. He then traveled in January 1894 to Brussels, where he had a moderately successful exhibition. A visit to his family in Copenhagen did not improve his frame of mind. He was to argue

Maruru
Colored woodcut for the planned publication of *Noa Noa*

Annah the Javanese, 1893
45 ⅝ x 31 ⅞ in. (116 x 81 cm)
Private Collection

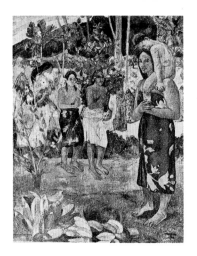

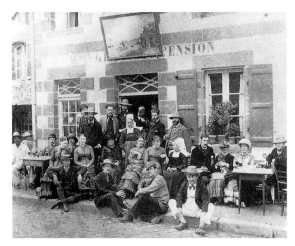

with Mette over pictures and money and each showered reproaches upon the other. Following this he returned to Paris.

With the coming of spring Gauguin, by nature restless, felt drawn back to Brittany, to that landscape where he had so often sought refuge when things were not going well. But when he arrived in Pont-Aven with Annah, the monkey, and some friends it was immediately clear that much had changed. The old inns were no longer there. "Mother Gloanec" had built a new hotel. The country people either ridiculed or insulted the strangely dressed arrivals. A trip to the harbor at Concarneau on 25 May 1894 ended in a hand-to-hand fight with sailors. Gauguin, who pitched in at full strength, broke his ankle and had to be transported back to Pont-Aven on a cart. There he then had to spend two months in hospital, "barely human through so much morphine." When he was at last able to return to Paris, yet another cruel disappointment was awaiting him. Annah had disappeared, having looted the studio — leaving only the pictures.

The chain of failures and false moves was not to be broken. The Musée de Luxembourg had turned

A French newspaper, probably the *Mercure*, printed a steel engraving of Gauguin's picture *Ia Orana Maria* (see page 35). Gauguin colored the cutting and included it in his book *Noa Noa*.

The Pension Gloanec at Pont-Aven c. 1890

down Gauguin's offer of his picture *Ia Orana Maria*. The Ministry of Culture, having promised in 1891, before Gauguin's departure for the South Seas, to purchase one or more works on his return, now refused to buy any at all. Nor was the Ministry prepared to entrust him with any further responsibility. No doubt news had reached Paris of his lifestyle on Tahiti. Gauguin decided to leave Europe once and for all and to return to the South Seas. He needed money to do this and a second auction in the Hôtel Drouot was to cover the costs. Gauguin asked the Swedish writer August Strindberg to write a foreword for the catalogue, but Strindberg turned down the request and wrote a long letter laying out the reasons for his refusal:

"I cannot get hold of your art and I cannot like it. (I have no grasp of your art, which this time is exclusively Tahitian.) But I know that this admission will neither surprise nor wound you, for it appears that the hatred of others can do nothing but strengthen you: your personality relishes the antipathy it excites, in its anxiety to remain entirely intact. . . .

What is he then? He is Gauguin, the savage who hates the constraint of civilization, something like a Titan, jealous of the Creator, who in his spare time makes a little creation of his own; he is a child who takes his toys to pieces and uses them to make others, one who rejects and defies, preferring to see the sky red rather than blue with the crowd. . . .

Bon voyage, Maître! only, come back to us and to me. By that time perhaps I shall have learnt to understand your art better, and that will enable me to write a real preface for a new catalogue in a new Hôtel Drouot; for I too am beginning to feel an immense need of turning savage and of creating a new world."[36]

August Strindberg
Photograph, c. 1900

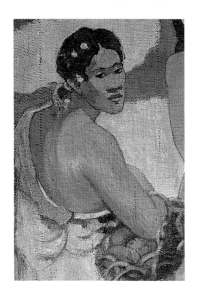

Without further ado Gauguin used this letter in place of a foreword and considered it to be so important that he included it many years later in his *Avant et après* (Before and After).

But the auction in February 1895 was a flop. Gauguin found himself obliged to make pseudo-sales to his friends in order to avoid being subjected to complete public humiliation. So after all the costs had been met he was, as he informed Mette in a letter, "464.80 francs the poorer!" By selling some works to a private collector in Paris he managed, with the greatest of difficulty, to get together a few thousand francs for the journey. Without any great leave-takings, on 29 June 1895 he boarded the *Oceania* in Marseilles. He had not told his family in Copenhagen of his imminent departure. Unnoticed he left Europe — this time for ever.

Maternity , 1899
37 x 28 ³⁄₈ in. (94 x 72 cm)
Detail
The Hermitage, St. Petersburg

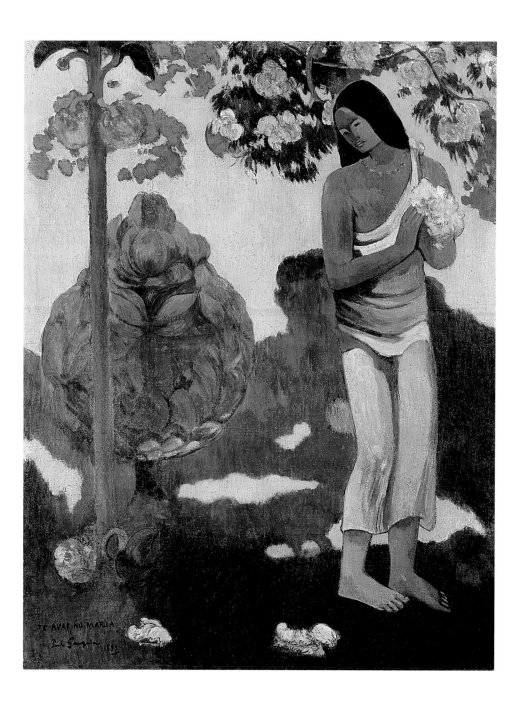

The Month of May (Te avae no Maria)
1899
38 ⅛ x 29 ⅞ in. (97 x 76 cm)
The Hermitage, St. Petersburg

The Second Journey
1895–1903

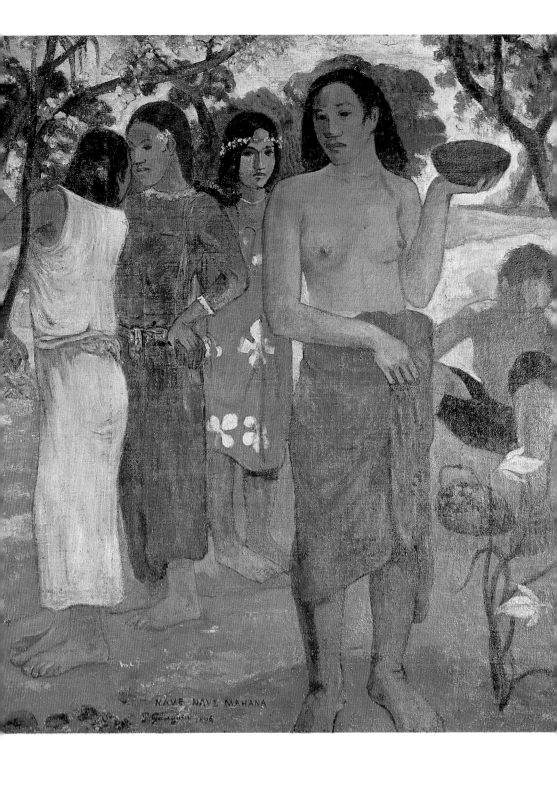

NAVE NAVE MAHANA
P. Gauguin 1896

Paradise Lost

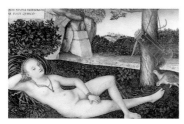

On the long sea voyage from Marseilles to Tahiti there was ample time for Gauguin to take stock of his life so far and to forge plans for his return to the South Seas. He no longer had any desire to live in Europe and yet he did want the civilized world to speak his name with respect. Unbowed he had regained confidence in the significance and the value of his own work. "I was fascinated by this idyllic island and its unspoiled inhabitants. And therefore . . . I will go back there now. In order to create something new, you have to go back to the original source, and to the childhood of the human race," he wrote a few days before leaving France to the journalist Eugène Tardien from the *Echo de Paris*.[37]

Gauguin was now forty-seven years old and he was not in good health. A nasty sore on his foot would not heal and he was bothered by feverish attacks. What he did not know was that these were symptoms the first signs of syphilis, which he had contracted in Paris.

Having at long last arrived in Tahiti, Gauguin rented a piece of land on the coast, in Punaauia. He was not able to return to Teha'amana in Mataiea. "Temporary marriages" were an accepted custom in those days in Polynesia. If a man no longer wanted to live with his wife or if a woman wanted to end a marriage, she could simply return to her parents without any loss of face. Teha'amana had done this after Gauguin's departure and had remarried in the meantime.

By winter Gauguin had managed to build and furnish his new house. The walls of the studio were decorated with photographs and various sorts of mementos that he had brought along with him from France. In addition there was a bedroom and

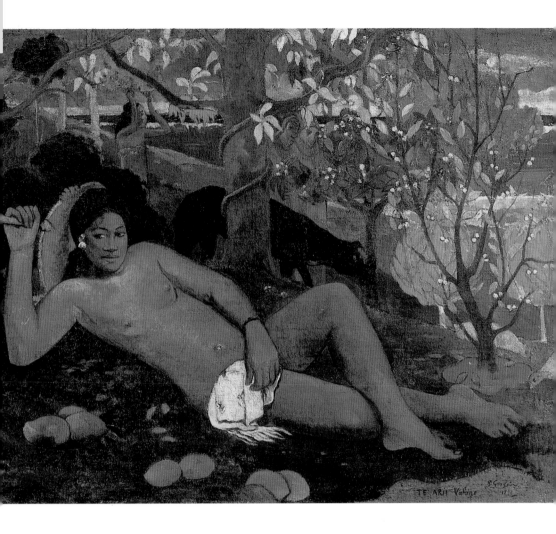

The Noble Woman (Te Arii Vahine)
1896
38 ¹/₈ x 51 ¹/₈ in. (97 x 130 cm)
The Hermitage, St. Petersburg

a shed for a horse and cart. He was painting again and had found a model in the fifteen-year-old Pahura. In a letter to Daniel de Monfreid in April 1896 Gauguin describes his portrait of Pahura, *Te Arii Vahine*, as his best work to date: "I have just finished a picture 1 x 1.30 which I think is better than anything else so far: a naked queen is resting on a green carpet, a girl is plucking fruit, two ancients near the large tree are discussing science, beach in the background . . . I think that as far as color is concerned I have never done anything which has such grand, such weighty fullness of tone. The trees are in blossom, and the dog is on

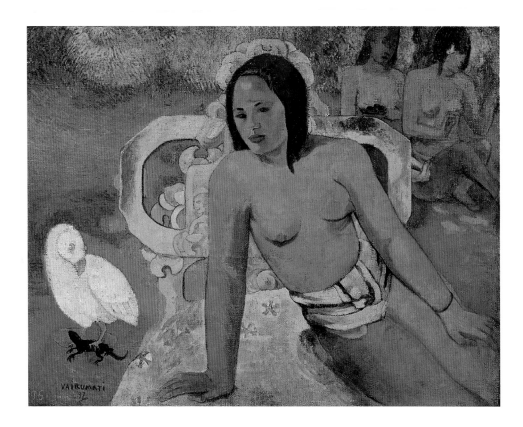

guard, the pigeons are cooing. Why should I send you the picture, there are already so many and they are not selling and only cause a huge fuss. This will cause a much bigger fuss!"[38]

Gauguin's positive, combative mood, however, was not to last long. Money pledged to come from Europe failed to appear yet again. Thus he was faced with the prospect of a hard winter. Nor did his situation improve in 1896. The Minister for the Fine Arts, Monsieur Roujon, consistently refused to buy any work by Gauguin, although he did send two hundred francs to the painter himself. But Gauguin spurned this "gift" and sent it back to Paris, along with a letter phrased in no uncertain terms.

Gauguin was now surviving on "nothing but drinking water and some boiled rice." In the

Vairumati, 1897
28 ¾ x 37 in. (72 x 94 cm)
Musée d'Orsay, Paris

summer, with his health seriously undermined, he had to go into hospital in Papeete, where he did recover a little. When Pahura gave birth to a baby daughter — Gauguin's third child out of wedlock — he painted the picture *Bé-Bé*. An angel is hovering behind her and in the very depths of the picture space lies a naked form on a bed. It seems that Gauguin was able, quite without contrivance, to unite fact and fiction in one picture; this picture also shows that he was now taking up Christian themes once again. In his despair he was seeking refuge in the Bible, for Jesus of Nazareth had upheld nonviolence and love as the highest principles of all. All Christian human beings should be united by equality, brotherliness, and justice. Gauguin compared Jesus' acts and teachings with the misdeeds of missionaries on Tahiti: "Missionaries are not real people any more, they have no consciences: each one a carcass at the beck and call of some order. Without a family, without love, without even one of those feelings which seem so important to us. Someone says 'Kill!' to them — so they kill. It is God's wish. 'Conquer this piece of land!' — and they conquer it."[39] The painter, already unpopular with the white lords of the colony, was now openly resisting officialdom, the Catholic Church, and the forces of law and order. He, lonely, "savage," with nothing more to lose, directed his venomous scorn at the oppressor — an unequal battle.

Then Gauguin's illness took a further turn for the worse. Tiny, painful lumps formed in his eyes, and the open sores on his legs increased in size. He was tormented by constant blackouts and high temperatures. In this condition he received news of his daughter Aline's death. Only twenty-one years old, she died of a "painful bout of pneumonia."

During his first visit to the South Seas in 1893 Gauguin had written his *Notes for Aline*. She had

Bé-Bé, 1896
26 x 29 ½ in. (66 x 75 cm)
The Hermitage, St. Petersburg

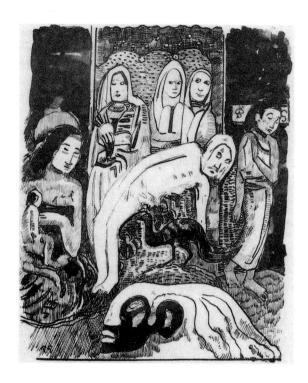

always been the closest to him of all his children, and he wanted to share with her his views on art, life, and politics, as well as his own experiences too. Neither this nor *Avant et après* were published until a year after his death.

In desperation Gauguin wrote to Daniel de Monfreid: "Never a chance, never any joy. Everything is always against me so that I have to cry out: 'God, if you do exist, I hereby accuse you of injustice and wickedness.' Yes, when I heard the news of poor Aline's death I despaired of everything, I laughed just as though someone had thrown down some gauntlet. So what's the point now of virtue, work, intelligence?"[40]

Les Saintes Images
Drawing for "Avant et après".
From the French edition, 1923
(Les Editions G. Crès et Cie)

Avant et après (Before and After)

A quoi penses tu? Je ne sais pas
Untitled
Drawings for "Avant et après".
From the French edition, 1923

Throughout his life Gauguin accompanied his painted works with written texts, always finding a new, thought-provoking way to express his opinions and attitudes regarding artistic questions. From his last home in the South Seas, the island Hiva Oa in the Marquesas, he more than once addressed himself to the art critic of the *Mercure de France*, André Fontainas, whom he had never met personally. He expounded his views on the latest issues in the world of art whilst also discussing his own works. In 1902 he sent him a lengthy manuscript with the title *Avant et après*, with the request that he should make inquiries as to its possible publication. How or even whether the art critic responded is not known. He did, however, give the manuscript to Charles Morice, who had begun to write a biography of the painter who had disappeared somewhere in the South Seas.

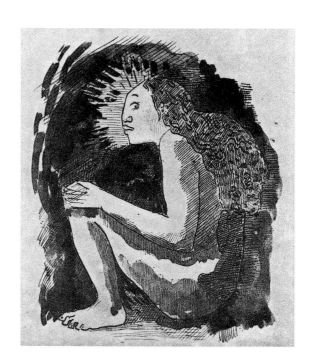

D'eux sont nés les Dieux suivants ;
Elle enfanta Teirii et il était Dieu
Téfatou – Rouanoua.
Quand le Dieu Roo, saisissant ce
qu'il y avait dedans, sortit par le cô
du sein de sa mère.
La femme accoucha ensuite de ce qu'elle
contenait encore ; il en sortit ce qui
s'y trouvait encore renfermé :
L'irritation ou présage des tempêtes,
la colère (ou l'Orage) la fureur ou
un vent furieux, la colère apaisée
ou la tempête calmée).
Et la source de ces esprits est dans le lie
D'où sont envoyés les messagers.



Eternité de la Matière –

Dialogue entre Téfatou et Hina (les génies
de la terre – et la lune.

Hina disait à Fatou;"faites revivre (ou
ressusciter) l'homme après sa mort.
Fatou répond : Non je ne le ferai point
revivre . La terre mourra ; la végétation
mourra ; elle mourra ,aussi que les hommes
qui s'en nourrissent; le sol qui les produit
mourra . La terre mourra , la terre finira;
elle finira , pour ne plus renaître .
Hina répond : Faites comme vous voudrez
moi je ferai revivre la Lune. Et ce que
possédait Hina continua d'être ; ce que
possédait Fatou périt, et l'homme dut mourir

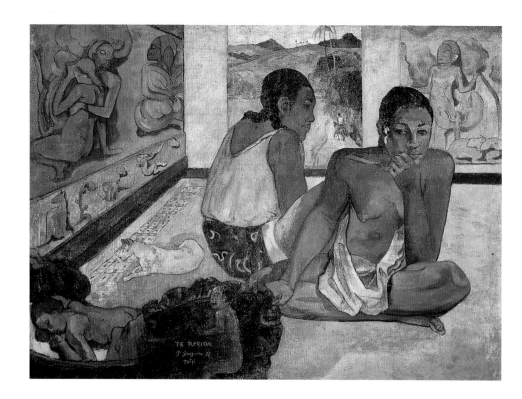

Gauguin's considerable trust in Fontainas and his influence in the Paris art world is evident from his dedication at the beginning of the work:

"And it is to M. Fontainas that I dedicate this work, which grew in the realms of subconscious feeling, which came into the world in the loneliness of the wilderness, which has been told by a naughty but intermittently thoughtful child, and who is, despite everything, in love with beauty. The beauty of the individual is our only really human quality."

The manuscript was nevertheless, not published in its entirety until 1918, by which time Gauguin's art was already beginning to have an impact on the world's leading galleries, raising public interest in his adventurous life. A mere two years later the Munich publisher Kurt Wolff was to bring out a German translation with the title *Vorher und Nachher*.[41]

Pages 74/75 from *Ancien Culte Mahorie* by J.-A. Moerenhout. Gauguin copied out parts of this work and decorated the manuscript with delightful drawings and watercolors.

The Dream (Te rerioa), 1897
37 ³⁄₈ x 52 in. (95 x 132 cm)
Courtauld Institute Galleries, London

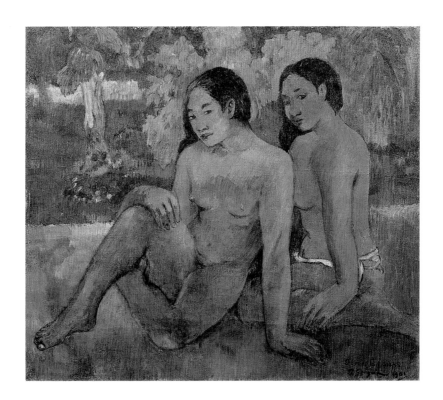

And the Gold of their Bodies . . .
28 ³/₈ x 36 ¹/₄ in. (72 x 92 cm)
Musée d'Orsay, Paris

"This is not a book. — A book, even a bad book is a great thing." These are the opening words of *Avant et après,* and the words "Ceci n'est pas un livre" recur like some incantation throughout the text. With unrelenting candor Gauguin sets out his views on Europe, morality and pseudo-morality, love and sexuality, conditions in the then French colonies, literature and philosophy — and perhaps precisely because of this candor he does his best to forestall any counterattacks on the part of the public by declaring: "The best thing would be to stay silent. But it is galling to have to remain silent when you feel like speaking."[42] And the emigrant had plenty to say. He was ill, and felt deserted and misunderstood. So he at least wanted to write about what was weighing him down, he wanted to justify himself and what he was doing, he wanted to make a stand against all those things that he felt were stifling, unfair, obsolete, and inhuman.

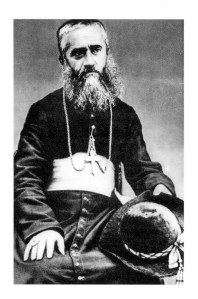

Joseph Marten, Bishop of Papeete

The Great Buddha, 1899
38 ¹/₈ x 28 ³/₈ in. (97 x 72 cm)
The Hermitage, St. Petersburg

He returned repeatedly to the role of the Catholic Church in the modern world, comparing its conditions with the demands of the Gospels and coming to some devastating conclusions. He even entered into a kind of indirect dispute with the Bishop of Atuona over issues which seriously concerned him, sending him a manuscript "The Modern Spirit and Catholicism." "In answer I received by roundabout means a huge tome, presumably to crush me, illustrated with splendid photographs dealing in detail with the history of the Church from its earliest days. Again by roundabout means I returned the book along with my assessment of it, or, if you like, with my critique of it. And that is as far as the discussion went."[43] This was hardly surprising in view of the artist's ruthless censure: "The Catholic Church no longer exists as a religion. Too late to try to save it now. Proud of our conquests and confident of the future we call out 'Halt there!' to this cruel, hypocritical Church. We tell her that we hate her and why we hate her . . . In the twentieth-century the Catholic Church is a rich Church. She has plundered all the philosophical texts in order to falsify them and hell reigns supreme."[44]

Gauguin's observations on love, marriage, and sexuality would also hardly have gladdened the Bishop's heart. We know, particularly from letters to Daniel de Monfreid how preoccupied Gauguin was with his separation from his wife and children and what feelings of guilt he was trying to compensate for. Now he writes in bitter tones: "I am not acquainted with love, and the words 'I love you' would most certainly stick in my throat. . . . Clever women sense this, which is why they don't like me." The artist in turn leaves no doubts as to the kind of woman he favors. "I love women that are rounded and base. I mind it if they have a mind of

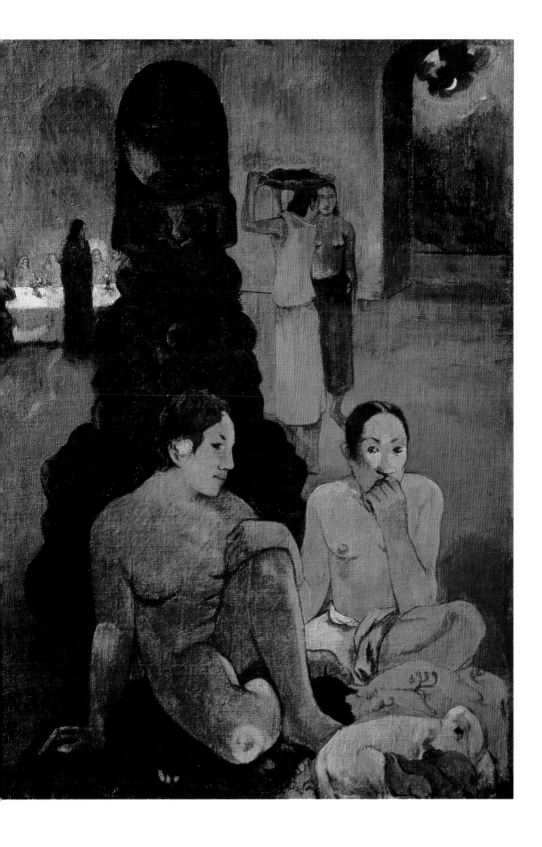

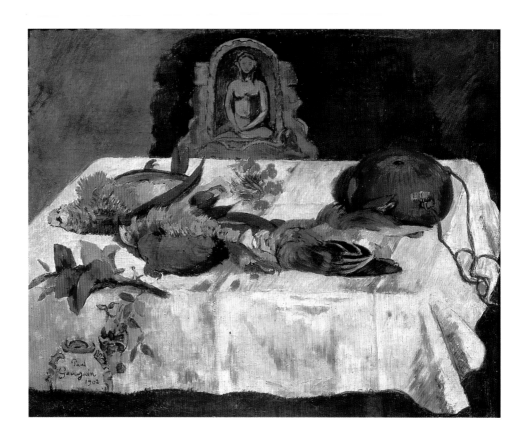

Still Life with Parrots, 1902
24 ³⁄₈ x 29 ⁷⁄₈ in. (62 x 76 cm)
Pushkin Museum, Moscow

their own, that kind of mind which is too mindful for me. I have always wanted a fat mistress and never found one. Mine have all been as flat as a pancake and the joke has always been on me."[45] He sees conventional morality as being on the point of disintegration: "It seems to me as though morality, like science and everything else, is changing into a new form of morality which is wholly at odds with the current version. It always seems to me as though marriage, family, and all those other lovely things that people are always telling me about so insistently are disappearing at a rate of knots."[46] He even had some advice for his readers as to how they could avoid knuckling under to bourgeois norms: "Take it to your hearts and nail something indecent to your door. From that moment onwards

you need have nothing more to do with decent people, those most unbearable creatures in God's whole wide world."[47]

Gauguin also addressed artistic questions in his manuscript. He never lost interest in the developments in art in France and cared about what happened to painters he knew. Looking back over his life he paid particular attention to the period with van Gogh. Four lengthy passages are devoted to his friend, and one story about him, *The Pink Crabs*, powerful and direct, is particularly moving. In the first part, which Gauguin called "Beforehand: Winter 1886," there is a description of van Gogh hopelessly underselling one of his pictures for a few pence in an antique shop, only to give the hard-won cash to a "poor soul just released from St. Lazare" who was hoping "for business."

Under the heading "Afterwards" Gauguin writes: "A day will come that I can see now as though it were already here. I will enter Room No. 9 in the Hôtel des Ventes, the auctioneer will be selling a collection of pictures, I join in: 400 for *The Pink Crabs*, 450, 500. Come along, gentlemen, they're worth much more than that! No one else? Going, going, gone! Vincent van Gogh's *The Pink Crabs*."[48]

Gauguin describes their time together in Arles and defends himself against suggestions that he was in part responsible for van Gogh's death. He also gives a detailed account of his warm admiration for Edgar Degas and his more mixed feelings about Emile Bernard. Writing about Degas' powerfully individual style he declares enthusiastically: "Why does he sign his works? He needs to less than most, less than any!"[49] Bernard, on the other hand, does not show up so favorably: "In the words of one art lover on the subject of this pioneer: 'He copies a

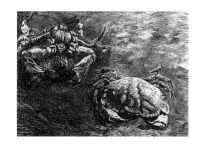

Vincent van Gogh, *The Pink Crabs*, 1889
18 ½ x 24 in. (47 x 61 cm)
Whereabouts unknown

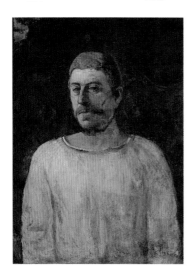

drawing, then he copies the copy, and so on until, like an ostrich with its head in the sand, he finds that it no longer bears any resemblance to the original — and then he signs it.'"[50]

Light is thrown too on Gauguin's view of himself as an artist by two contributions by other writers which he includes in his manuscript. On the one hand there is the long letter by Strindberg which had served as a foreword for the catalogue for the auction of Gauguin's works in the Hôtel Drouot in 1894 (p. 63) and on the other hand there is a contribution by Achille Delaroche with the title "An Aesthetic View: on the painter Paul Gauguin." It is startling to find that, like the art critic Albert Aurier, Delaroche, about whom we know nothing, also comes to the conclusion that only the vast dimensions of monumental walls would do justice to Gauguin's new style of painting. And in grandiose terms he declares: "The light frescoes of a Gauguin would adorn the walls, and a symphony by a Beethoven or a Schumann would be mysteriously heard, while poetic words would ceremoniously intone the saga of the odyssey of the human race."[51]

But that was not to be. The artist's inner longing to be able to return to Paris in triumph was not to be fulfilled. He wrote: "Work without end — what would life be otherwise? We are what we have always been and always will be, vessels at sea rocked by the wind." A few lines later he writes: "I think life only makes sense if you live it according to your own will or at least according to the potential of your own will. Virtue, good ,and evil are words. If you don't break them, to build a building. They only make any sense if you know how to apply them." And he goes on stubbornly: "To put yourself into your Maker's hands means to destroy yourself and die."[52] He gives some cutting

Self-Portrait nearing Golgatha, 1896
29 ⁷/₈ x 25 ¹/₄ in. (76 x 64 cm)
Museu de Arte, São Paulo

advice for those of faint heart: "You have to be careful. Keep your hats on, your inspiration might fly away."[53] When Gauguin wrote these lines he knew in his heart that there was now no chance of his ever leaving the Marquesas again. So on the last page of the manuscript he returns to his own self-imposed exile: "Here in Atuana on the Marquesas it is turning very dark outside my window, the dances are finished, the sweet songs have died away. But it is not silent here. The winds are shaking the branches in a mounting crescendo, the great dance is starting, the cyclone is raging. Mount Olympus is joining in, Jupiter is sending lightning bolts, the Titans are storming the cliffs, the river is bursting its banks. Huge breadfruit trees are being uprooted, coconut palms bend their trunks and their crowns brush the earth, everything is fleeing, and the rocks, trees, and corpses, are all torn out to sea. A shattering orgy of outraged gods.

The sun shines again, the proud palms have their plumes back, as do the people. The agony is over, joy returns, the mother smiles on her child. The reality of yesterday becomes a fable and is forgotten."[54]

Nevermore, 1897
23 ⅝ x 45 ⅝ in. (60 x 116 cm)
Courtauld Institute Galleries, London

Where Do We Come From? What Are We? Where Are We Going?, 1897
54 ¾ x 147 ⅝ in. (139 x 375 cm)
Museum of Fine Arts, Boston,
Tompkins Collection

Gauguin's "View of the World": Where Do We Come From? What Are We? Where Are We Going?

During the course of 1897 Gauguin referred increasingly to his own death in letters and other writings. In the autumn he noted down that "The artist dies, his heirs make a grab for his works, sort out the copyright, his estate, and whatever else there might be to do. Now he has been stripped to the bone. I think about these things, and am going to strip myself first: it gives me a sense of relief."[55] He starts a new work — large, over twelve feet in length, without drawing anything first — painting directly on to the canvas. With *Where Do We Come*

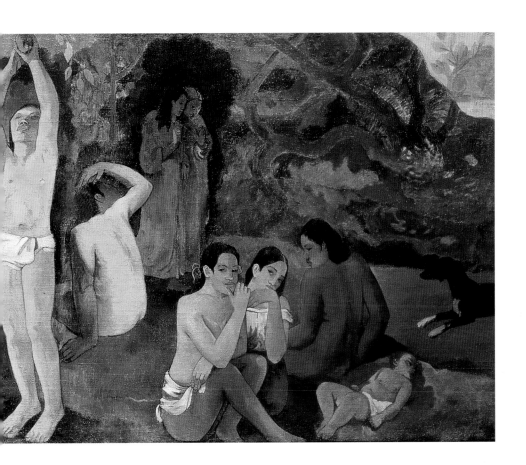

From? What Are We? Where Are We Going? he wanted to give expression through his painting to his faith, his view of life, his artistic insights, and his intentions.

"In the bottom right-hand corner there is a sleeping child, then three cowering women. Two figures dressed in purple are deep in conversation. A crouching figure which defies perspective, and is meant to do so, looks very large. This figure is raising its arm and looking in astonishment at the two women who dare to think about their own fate. The central figure is picking fruit from a tree. Two cats by a child. — A white goat. The idol is raising both its arms with rhythmic energy and seems to be pointing to somewhere beyond here.

The Great Divinity (detail from *Where Do We Come From? What Are We? Where Are We Going?*)

The large picture *Where Do We Come From? What Are We? Where Are We Going?* in Gauguin's house in Atuona, June 1898

Detail: *The Old Woman*

A cowering girl appears to be listening to the idol. An old woman, close to the end of life, completes the circle. She is ready to accept her fate. At her feet a strange, white bird with a lizard in its talons symbolizes the futility of empty words . . ."[56]

"I have painted a philosophical work on this subject, which could be compared to the Gospels. I think it has worked," as Gauguin later wrote to Daniel de Monfreid, and elsewhere he describes the picture to his friend: "The two upper corners are chrome yellow, with an inscription on the left and my signature on the right, as though it were a fresco, painted on a gold ground, with damaged corners."[57]

Gauguin had therefore two purposes for this huge painting. On an artistic level he set it on a par with fresco paintings. As far as content went he saw it as a "philosophical work." Did he do justice to his own intentions?

The underlying structure of this painting is made up of three groups of human figures. On the right, three women plus a child represent birth and childhood. In the center a woman is picking an apple. Here Gauguin is making reference to the biblical story of our fall from Paradise. Eve is taking an apple from the tree of knowledge, which reveals to her the nature of love but at the same time throws her into the pit of original sin. To the far left of the picture an old woman is crouching down, a symbol of death.

The composition and disposal of color by no means create the impression of a work completed in haste, which might be expected if one takes into account the conditions under which it came into being. There is no trace of the painter's poor state of health, both mental and physical: on the contrary, the picture radiates peace and equanimity. The main figures in the composition are ranged

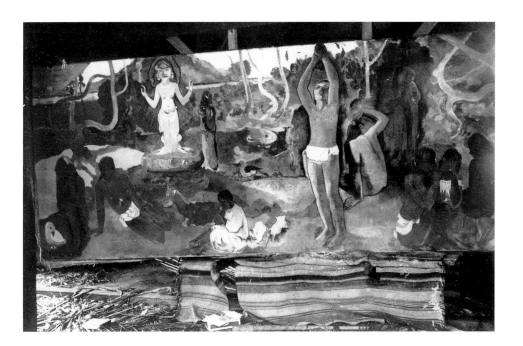

on three picture planes, one behind the other, stretching backwards into the painting, barely touching each other and carefully worked on the flat surface of the painting. The colors also give a sense of having being pared back to a minimum and are largely built around two contrasting pairs: blue and orange, and red and green. As a result of this the picture, by virtue of its artistic qualities alone, seems to acquire a monumental aspect quite independent of its real dimensions. This picture would make a fine fresco.

The painting's figures barely relate to one another nor to the idol in the left-hand third of the picture, which represents the divine in its widest sense. Instead they are integrated into the surrounding landscape, they are part of Nature and of Creation, to which they belong, from which they come and to which they will return — never mind what they have done, how they have related to each other, or what religion they have followed. It is a portrayal of our earthly lives, it is a plea for

Février 1898-

Mon cher Daniel.

Je ne vous ai pas écrit le mois dernier, je n'avais plus rien à vous dire sinon répéter, puis ensuite je n'en avais pas le courage. Aussitôt le courrier arrivé, n'ayant rien reçu de Chaudet, ma santé tout à coup presque rétablie c'est à dire sans plus de chance de mourir naturellement j'ai voulu me tuer. Je suis parti me cacher dans la montagne où mon cadavre aurait été dévoré par les fourmies. Je n'avais pas de révolver mais j'avais de l'arsenic que j'avais thésaurisé durant ma maladie d'eczéma: est-ce la dose qui était trop forte, ou bien le fait des vomissements qui ont annulé l'action du poison en le rejetant, je ne sais. Enfin après une nuit de terribles souffrances je suis rentré au logis. Durant tout ce mois j'ai été tracassé par des pressions aux tempes, puis des étourdissements, des nausées à mes repas minimes. Je reçois ce mois-ci 700f de Chaudet et 150f de Mauffra: avec cela je paye les créanciers les plus acharnés, et recontinue à vivre comme avant, de misères et de honte jusqu'au mois de: Mai où la banque me fera saisir et vendre à vil prix ce que je possède entre autres mes tableaux. Enfin nous verrons à cette époque à recommencer d'une autre façon.

Il faut vous dire que ma résolution était bien prise pour le mois de Décembre alors j'ai voulu avant de mourir peindre une grande toile que j'avais en tête et durant tout le mois j'ai travaillé jour et nuit dans une fièvre inouïe. Dame ce n'est pas une toile faite comme un Puvis de Chavannes, études d'après nature, puis carton préparatoire etc. Tout cela est fait de chic au bout de la brosse, sur une toile à sac pleine de nœuds et rugosités aussi l'aspect en est terriblement fruste. On dira que c'est lâché etc.....

D'où venons nous? que sommes nous? où allons nous?

Letter from Gauguin to Daniel de Monfreid, with a sketch of his painting *Where Do We Come From? What Are We? Where Are We Going?*

joie de vivre, which each one of us ought to delight in to the full before social pressures or even the purely biological process of aging rob us of one pleasure after another. That, pure and simple, was Gauguin's message, which he translated so successfully into his pictures.

Having completed this painting in a few days and with still no help from Europe, Gauguin decided to put an end to his own life. He found a hiding place high up in the woods and swallowed a quantity of arsenic. But it only made him retch and he was unable to keep the poison down. After two days, still suffering from horrific bodily pains, he returned home. Thrown back into life against his will, he nevertheless resumed the struggle. "It is not a question of self-sacrifice, it is a question of giving in to defeat."[58]

After this he secured a position as an illustrator in the Land Registry, determined not to paint any more until he had paid his debts and had saved enough money to live on for at least two years. He became increasingly aggressive towards the colonial administration, writing critical pieces in the paper *Les Guêpes* (The Wasps), in which he entered into battle against the Bishop and the administration and took up the local cause. In *Avant et après* he wrote: "At latitude 17 degrees south it is just like everywhere else, with Chief Advisors, Officials, Constables, and a Governor. Society's elite. And the governor proclaims: 'Look, children, all you need do here is to collect up the cash.'"[59]

In autumn 1898 hope at last arrived from France. Emile Vollard, an art dealer who had owned a gallery in Paris since 1893 and who was now, along with Henri Durand-Ruel, the leading dealer in contemporary art, had bought nine of Gauguin's pictures for a total of one thousand

Title woodcut for *Le Sourire*

francs and put on a show of his works. The critic André Fontainas gave it a favorable review in the *Mercure de France* and there was renewed interest in France in the painter who had disappeared somewhere in the South Seas. Two years later Vollard and Gauguin signed a permanent contract: Vollard was to transfer three hundred francs a month to Tahiti and Gauguin was to send him all he produced. The money was somewhat sporadic in arriving but Gauguin was at least able to live from it after a fashion.

At the beginning of 1901 Gauguin had to go back into hospital, for the sores on his legs were becoming septic. Hardly back on his feet, he felt he wanted to dispose of his property on Tahiti in order to retreat further into unexplored territory, possibly the Marquesas islands. "The world is so stupid that as soon as you presented it with paint ings with new, terrible aspects it would instantly understand Tahiti and find it delightful. My Tahiti pictures have turned my Brittany pictures into 'rose water.' My Tahiti pictures will become 'eau de cologne' when people see my Marquesas pictures."[60]

Gauguin then did indeed move in 1901 to Hiva Oa, an island about twenty-five miles long in the Marquesas. On arrival he did everything he could to win over the Bishop and the local officials. He was polite and put on a show of being a conservative Frenchman. But he was only doing it because the Mission owned land which was not too expensive and was suitable for building on and which he needed. His ploy worked and the Catholic Mission let a plot to him to build a house on. But no sooner was his "House of Pleasure" finished than he was taking up arms against the Church again in his usual way. The Bishop and his people felt used and betrayed.

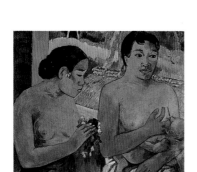

The Offering, 1902
The E. G. Bührle Collection, Zurich

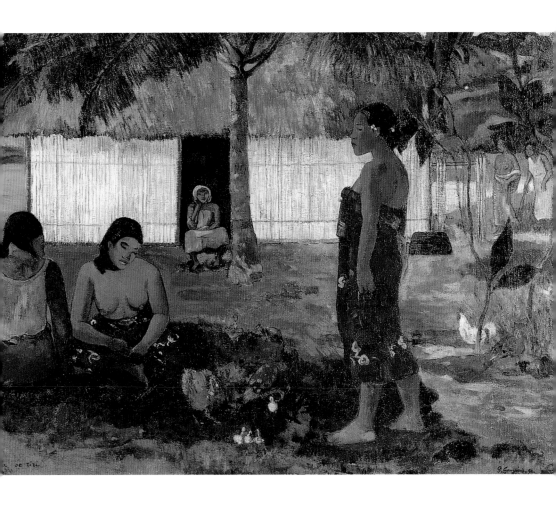

Why Are You Angry? (No te aha oe riri?), 1896
The Art Institute of Chicago,
The Mr. and Mrs. Martin Ryerson
Collection

Thanks to the contract with Vollard, Gauguin now had a more or less steady income for the first time in many years. But just as when he had come into his inheritance in Paris, the source of his own creativity dried up. Instead of painting he became involved in extended disputes with officials, the Bishop, and the police, above all a certain Corporal Charpillet.

The French who lived on the island would avoid the "anarchic artist" whose life amongst the native islanders was always causing some scandal. Becoming increasingly dependent on alcohol Gauguin was frequently spending the evening drinking and dancing in his "House of Pleasure" with Marques-

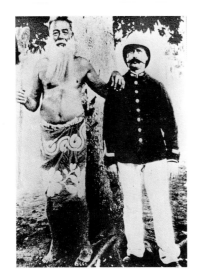

French gendarme and Polynesian chieftain

an friends. "I need everything. I can't force it but that is what I want. Let me catch my breath and then, recovered, cry out: 'Fill them up, fill them up again!' Let me then run, run out of breath and die a wild death. O wisdom . . . you bore me so. All you do is yawn."[61]

In the end he stopped painting altogether and devoted his remaining energy to fighting the colonial administration. He stopped paying his taxes and managed to persuade the islanders to follow his example and, in addition, not to send their children to the mission school any more. He then enraged the Bishop by taking in a former housekeeper of his. And on top of all of this he never missed an opportunity to ridicule the hated Gendarme Charpillet, with the result that Charpillet would harass him at every turn and report him for anything, however trivial, which transgressed against local bye-laws or even against notions of "good taste."

The more unpopular Gauguin made himself amongst the island's French population, the more the Marquesans trusted him, affectionately mispronouncing his name as "Kokee." He defended islanders in several trials, much to the annoyance of the judge and Charpillet. "This odd man with his short shirt and a pareo (as worn by the islanders), with a green student's cap on his head, with badly swollen legs that were horrible to look at, and with a stick to lean on that he had carved himself, was now setting out to right all wrongs and to become a legend in his own lifetime."[62]

But in his heart Gauguin was filled with anxiety, worried about his health, and would have liked best of all to return to Europe. His long-standing friend Daniel de Monfreid, however, advised against this. "At the moment you are the fabulous, outrageous artist, who sends his confusing but inimitable

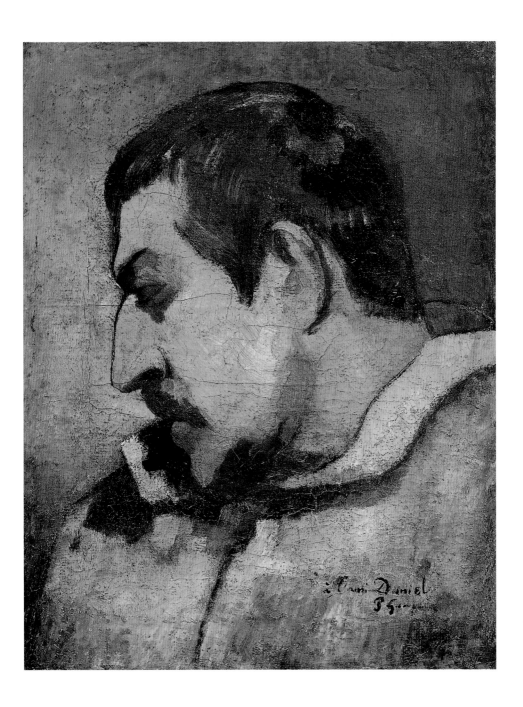

Self-Portrait (dedicated to Gauguin's
friend Daniel de Monfreid), 1896
16 x 12 ⅝ in. (40.5 x 32 cm)
Musée d'Orsay, Paris

works from far away in the Pacific Ocean — the creations of a great man, as it were, who has disappeared from the world. Your enemies (and you have plenty, like all outstanding figures who upset mediocrity) — they are saying nothing, they do not dare oppose you, the thought would not even cross their minds . . . in short you are benefiting from the unassailability of the great once dead. You have already become a part of art history."[63]

In April 1903 the colonial administration was at last presented with a chance to get rid of the hated thorn in their flesh, or at least to teach him a lesson. Gauguin had accused the gendarmerie of accepting bribes from smugglers. In the meantime, however, it turned out that he had been misinformed. He was therefore tried for slander and sentenced to three months in prison with a fine of a thousand francs. "I have to lodge an appeal on Tahiti. The journey, a place to stay, and above all lawyers' fees! How much is all this going to cost me? It will be the ruin of me, and my health will be completely destroyed. My whole life long I have to fall, to stand up again, only to fall once more, and so on. My old energy is seeping away from me day by day." This letter to Daniel de Monfreid ends with the sentence: "All these worries are killing me."[64] It was to be the last news from Gauguin to reach Europe.

On 8 May 1903 Paul Gauguin died alone in his "House of Pleasure." The colonial administration lost no time in disposing once and for all of the awkward rebel. The evangelical Pastor Vernier, who had often visited Gauguin during his last days, wrote to Daniel de Monfreid in Paris: "My astonishment turned to outrage when I heard that the Bishop had decided to bury Gauguin with the full trappings of Catholic pomp. And this did then indeed happen on Saturday 9 May, in other words

Head of a Tahitian Woman
Pencil on paper
12 x 9 ⅝ in. (30.6 x 24.4 cm)
The Cleveland Museum of Art, Mr. and Mrs. Lewis Williams Collection

Poèmes Barbares, 1896
25 ⅝ x 18 ⅞ in. (65 x 48 cm)
The Fogg Art Museum, Harvard University, Cambridge, Mass., Maurice Wertheim Bequest

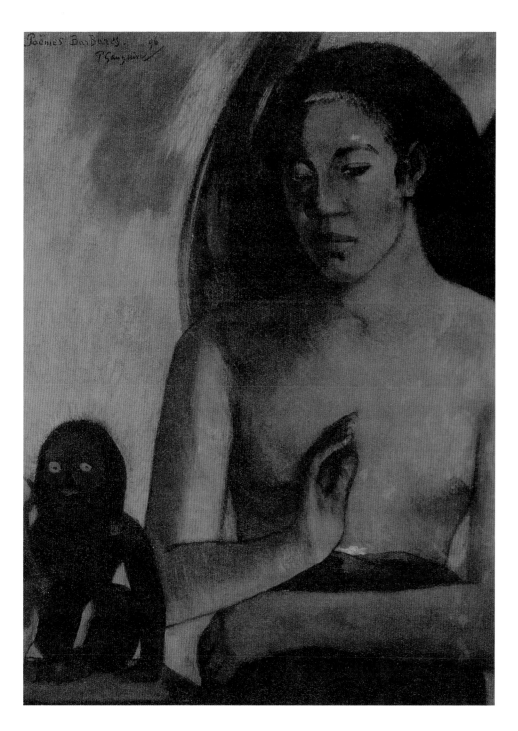

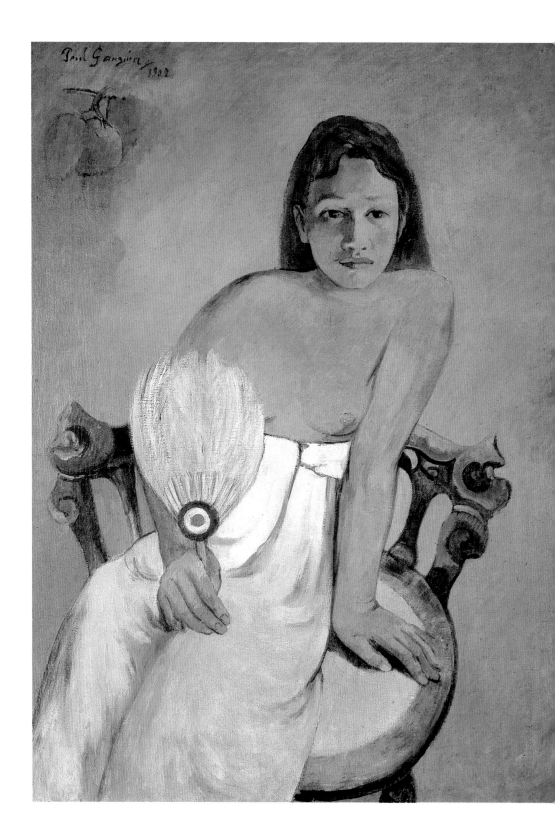

the very next day . . . A real conjurer's trick, as you must admit. And Gauguin has now been laid to rest in the Catholic cemetery, a holy place of the first order! In my opinion he should have had a civic funeral ceremony."[65]

That would also certainly have been what the painter would have wished. A few months before his death he had after all written of himself: "I was sometimes good and do not congratulate myself for that. I was often bad and do not regret that. I look at all these saints, I do not see any sign of life, and I am filled with doubt. They make sense in cathedral alcoves, but only there."[66] And a few pages later he says: "All my doubts have vanished. I am, and always will be, a savage."

Pahura with a Fan
Photograph, probably by Charles Spitz

Tahitian Girl with Fan, 1902
36 ¼ x 28 ¾ in. (92 x 73 cm)
Folkwang Museum, Essen

Late Victory

Even after his death Gauguin's personality and above all his work caused considerable dissent. In the same year as he died, in 1903, there were memorial exhibitions to him in the Autumn Salon and in the Galerie Vollard in Paris. Three years later 227 of Gauguin's works were shown in Paris. The painter's name was on everyone's lips. The Impressionists, from whose ranks Gauguin had after all emerged, seemed utterly outmoded to the younger generation of artists. The young painters were not moved by the appearance of the picture surface and the beauty of the light: new formulas held sway involving the expression of individual feeling, the simplification of form, the intensification of color, and the rejection of Nature as an ideal. Gauguin's maxim – that a picture should not be a copy of Nature but should originate "inside the painter's head" – could serve as a motto for the whole of classical Modernity.

While academics continue to discuss, often critically, the true significance of Gauguin, artists have long since accepted his work, taking from it what they wanted: Edvard Munch took Gauguin's woodcuts a stage further; Jugendstil adopted decorative features of his work; and Henri Matisse was enthused by the quality of the colors and the rhythm in his visual works. German Expressionist painting would have been unthinkable without Gauguin and van Gogh. In all of this it is therefore of no significance if any particular painter accepts or rejects Gauguin's work, for there is no question as to its impact on Modernity right up until the most recent past. Many of the "young savages" of the eighties declared their allegiance to Gauguin's oppositional stance and to his unrestrained style of painting. They viewed him as the first "drop out"

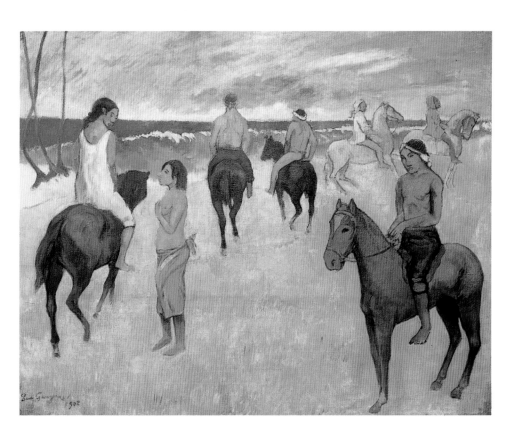

Riders on the Beach, 1902
28 ³/₄ x 36 ¹/₄ in. (73 x 92 cm)
Private Collection

who had scornfully opposed bourgeois society. The art world meanwhile marketed the outsider with ever increasing success. Between 1903 and 1950 there were over thirty major exhibitions in his memory, and the value of his work rose inexorably.

The art dealer Vollardn in the last years of his life paid the painter three hundred francs for one picture. After Gauguin's death the Greek collector Goulandris auctioned *Still Life with Apples and Flowers*, painted in 1901, for 104 million old francs. And the original manuscript of *Noa Noa*, which Charles Morice had got rid of for a few francs in an antique shop, was auctioned for no less than 250,000 francs in Paris in 1978. So far the highest price paid for a Gauguin picture is that fetched by the *Beach at Pouldu* from the Ford Collection in New York — $2.9 million.

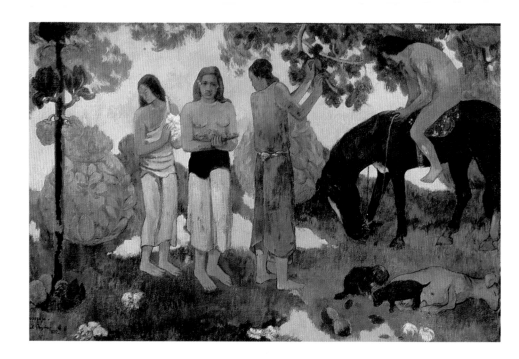

During his time in the South Seas Gauguin painted more than two hundred pictures, which were to form the main body of his work. Today these pictures have a magnetism all their own, attracting the public in many of the major collections throughout the world, and the international art community celebrates the romantic outsider of early Modernism as one of the greatest figures in the history of art. In 1985 seven thousand visitors a day poured through the crowded rooms of the Paul Gauguin retrospective at the Grand Palais in Paris before it moved on to Moscow and Leningrad. The exhibition had already been a magnificent success in Washington and Chicago and many would-be visitors in Paris had to be turned away. So, eighty-two years after Gauguin's death, his life's dream was to be fulfilled: his pictures made their triumphal return to Paris and at last took the city by storm.

Luxuriant Tahiti (Rupe rupe), 1899
50 3/8 x 78 3/4 in. (128 x 200 cm)
Pushkin Museum, Moscow

Biographical Notes

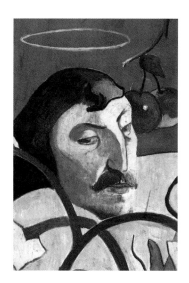

1848

Eugène Henri Paul Gauguin is born in Paris on 7 June. His mother is the daughter of the painter André François Chazal and his father the republican journalist Clovis Gauguin.

1849

Napoleon's coup d'état forces the Gauguins to flee France for Peru. Clovis Gauguin dies during the voyage.

1849–1855

Paul, his elder sister, Marie, and his mother live in the house owned by his great-uncle—Don Pio Tristan y Moscoso—one of the wealthiest men in Peru. Gauguin often recalls the happy years of his early childhood spent in these luxurious surroundings.
Returns to France.in 1855.

1856–1862

Paul goes to boarding school in Orléans, as his mother has to work to support the family.

1862

Moves to Paris, where Aline Gauguin finds work as a seamstress. Paul goes to the secondary school for boys.

1865-1867

The young Gauguin goes to sea, and is on board the *Chili* when his mother dies in St-Cloud. The renowned art collector Gustave Arosa becomes Paul's guardian.

1868

Enters the navy, and becomes a sailor on the *Jérôme-Napoléon*.

Page 101:
Self-Portrait with Halo, 1889

Jules Laure
Paul Gauguin at the age of two
Saint-Germain-en-Laye, Musée départemental du Prieuré

Flora Tristan, Gauguin's grandmother, copper plate engraving by Gerinler, 1847

1871

Finishes his military service and takes up a position in the bank Bertin, thanks to the influence of his guardian Gustave Arosa. He quickly rises to the position of *remisier*, an investment consultant. Gauguin himself speculates successfully on the stock market. In his free time he begins to paint and sketch.

1872

Gustave Arosa, a refined and sensitive man, introduces Gauguin to the Impressionists. He studies at the independent academy Colarossi alongside Emile Schuffenecker, a colleague from the bank who also shares his interest in art. Makes the acquaintance of the young Danish woman Mette Gad who is employed by a well-to-do Paris family as a governess.

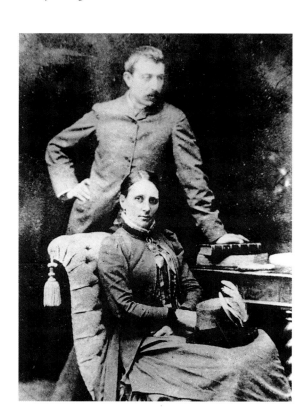

Gauguin's guardian Gustave Arosa
Photograph by Nadar

Mette and Paul Gauguin in
Copenhagen, 1885

Mette Gauguin in Copenhagen, 1885

1873

On 22 November Gauguin and Mette Gad are married.

1874

Their son Emile is born as the first of five children. Aline follows in 1877, Clovis in 1879, Jean René in 1881, and Pola in 1883. Pola is later to write a much acclaimed book about his father. Gauguin makes the acquaintance of Pissarro.

1876

One of his paintings, *Copse in Viroflay* is accepted by the official Salon d'Automne. It is to be the only work approved by the Salon during his life.

1877-1878

Gauguin's friendship with Pissarro and the Impressionists grows stronger. He rents a studio in Rue des Fourneaux 74, in Montparnasse.

1879

He takes part in the fourth Impressionist exhibition where he enters a marble sculpture. (He also takes part in the 1880, 1881 and 1882 exhibitions, and the final exhibition in 1886 in the Rue Laffitte where he shows nineteen pictures). Paints with Pissarro in Pontoise during the summer months.

1880-1882

Gauguin works for the insurance agency Thomereau. The summer is spent with Pissarro in Pontoise where he also meets Cézanne.

1883

He resigns his post at the insurance agency Thomereau, to dedicate himself wholly to painting. His social demise is now eminent.

Paul Gauguin with his children Clovis
and Aline in Copenhagen, 1885

A list of pictures painted by
Gauguin's friends
Musée du Louvre, Paris

1884

Hoping to be able to sell some pictures and to
live more cheaply, Gauguin moves with his family
to Rouen. As his hopes are not realised, and his
financial situation worsens, Mette and the children
move to live with her parents in Copenhagen.
In December, Gauguin accepts a position as a
representative for the linen manufacturers Dillies
and Co., and follows his family to Denmark.

1885

His first exhibition in Copenhagen is closed after
only three days, due, ostensibly, to public protest.
Gauguin returns to Paris with his four year old son
Clovis where they lead an impoverished existence.

1886

Clovis is sent to boarding school. Gauguin travels
through Brittany and joins the group of artists in
Pont-Aven where he makes the acquaintance of
Emile Bernard. This year is to prove a particularly

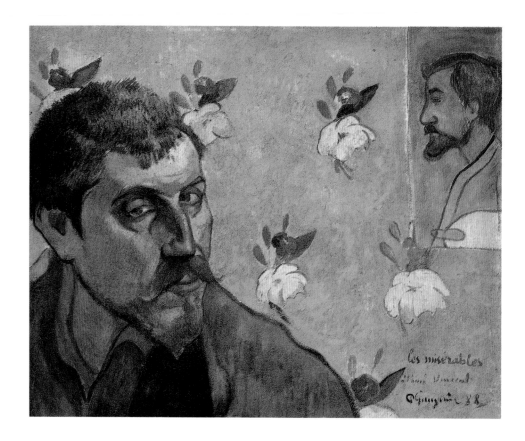

significant one for the development of Gauguin's art, as he is also meets Vincent and Theo van Gogh as well as Degas.

1887
Mette returns to take Clovis back to Denmark. In April, together with his painting companion Charles Laval, Gauguin heads for Panama and Martinique. The tropical landscape with all its penetrating colours is to have a lasting influence on him. Although Laval becomes seriously ill, Gauguin signs on a sailing ship in November and heads back to France. Through the introduction of Schuffenecker, Gauguin meets the painter Daniel de Monfreid, who is to become a lifelong friend.

Self-Portrait, Les Miserables, 1888
17 ³/₄ x 21 ⁵/₈ in. (45 x 55 cm)
Rijksmuseum Vincent van Gogh, Amsterdam

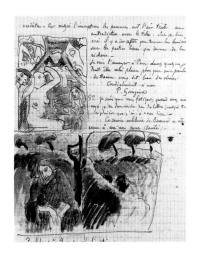

1888

In February Gauguin returns to Brittany to Pont-Aven to work alongside Sérusier, Laval, and Bernard. Vincent van Gogh, who has settled in Arles, convinces Gauguin to go and set up a `Studio du Midi' with him. In October Gauguin arrives in Arles. An intensive relationship develops between the two artists which, following hefty—sometimes even violent—disputes ends dramatically on 23 December. Gauguin then returns to Paris.

1889

Gauguin travels to Brittany again, firstly to Pont-Aven, and then in July to Le Pouldu. With some friends he decorates the guesthouse belonging to Marie Henry. He tries to gain support from friends to found an 'atelier aux tropiques' in Tongking (Indochina) or in the South Seas, but fails to convince Laval, Bernard or Mayer de Haan. In May Gauguin exhibits seventeen pictures in Café Voltini in the vicinity of the Paris World Exhibition. In early August he learns of the death of van Gogh (on 29 July) from friends in Le Pouldu.

1891

Gauguin is resolved to make a trip to the Tropics with or without his painting companions. An auction of his pictures at the Hôtel Drouot secures 7350 francs for the trip. He receives support from Octave Mirbeau who writes of his plans in 'Figaro'. Travels to Copenhagen on 7 March to bid farewell to his family.

After a farewell banquet in Café Voltaire, Gauguin departs from Paris on 31 March and sets sail from Marseilles on 4 April, arriving in Papeete on Tahiti on 18 June. At first he lives in Paea, 13 km south

A letter to Vincent van Gogh from Gauguin, 1889

Charles Laval
Self-Portrait 'à l'ami Vincent', 1888
Rijksmuseum Vincent van Gogh,
Amsterdam

Gauguin in Paris in winter
1893/94 infront of his picture
Te Faaturuma

of Papeete, but soon moves to Mataiea some 50 km from the capital on the south coast. Here he lives among the local people with a young woman by the name of Teha'amana (in his work he names his paramour Tehura). Begins his work on *Noa Noa*.

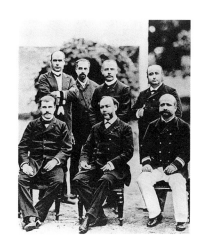

Governer Lacascade with colonial
officials, Papeete, c. 1893

1892

Financial problems befall him, his health also
degenerates to the extent that he suffers a heart
attack and requires hospitalisation. Sends nine
pictures to Mette in Copenhagen for an exhibition.
Due to his ever deteriorating financial situation, he
applies to the French authorities for a free passage
back to Europe.

1893

An exhibition in Copenhagen opens on 25 March
displaying fifty paintings which he had forwarded
to Mette. In June, Gauguin finally leaves Tahiti
and arrives - completely destitute - in Marseille on
30 August. Hopes for success with an exhibition
opening on 4 November with forty paintings and
two sculptures by Durand-Ruel, the forward to the
catalogue is written by Charles Morice. However,
the exhibition receives little acclaim. Notwith-
standing this setback, Gauguin works on the publi-
cation of Noa Noa with Morice. In September
Gauguin inherits around 13,000 francs from his
uncle Isidor in Orléans. Lives with Annah, a
Javanese girl, in Rue Vercingétorix 6 in Paris.

1894

In January he enters five of his works in an
exhibition in Brussels and travels to the opening.
Between April and December Gauguin spends his
time largely in Brittany. On 25 May he breaks his
ankle in a fight with a sailor and has to spend two
months in hospital. He returns to Paris in
November only to find that Annah has disappeared
and plundered his studio.

1895

On 18 February a second auction of his works
takes place at the Hôtel Drouot. Gauguin uses

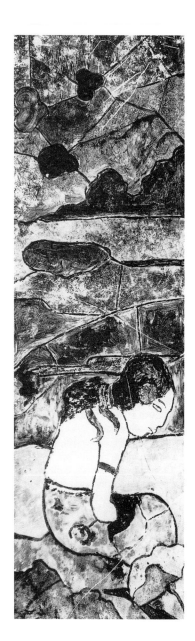

Tahitian Woman and Landscape,
c. 1893
Oil on glass, 45¾ x 13¾ in.
(116 x 35 cm)
(left pane), Musée d'Orsay, Paris

a letter from Strindberg as an introduction to the catalogue. The exhibition proves to be a total failure. On 3 July he boards the *Océanien* in Marseilles and departs once more for the South Seas. He arrives on 8 September in Papeete, and settles in the Punaauia district on the west coast of Tahiti. He continues his work on *Noa Noa*.

1896
Gauguin gives painting lessons to the lawyer Goupil's daughter in Papeete. He is once again forced into hospital for two weeks, this time due to his untreated syphilis. Lives together with a fourteen year old girl by the name of Pau'ura (Pahura). She gives birth to a daughter in December who dies shortly afterwards.

1897
1,200 francs arrive from Paris in January. Charles Morice publishes a revised edition of *Noa Noa* in the Revue Blanche in Paris. Receives a letter from Mette in April announcing the death of Aline. His health rapidly declines. Paints his confessional work *Where Do We Come From? What Are We? Where Are We Going?* Last letter to Mette.

1898
Following a failed attempt at suicide in January, from which he only slowly recovers, he takes up a position as draughtsman in the department of housing in Papeete. In November nine further paintings are exhibited in the Galerie Ambroise Vollard in Paris, including *Where Do We Come From? What Are We? Where Are We Going?* Gauguin founds the satirical monthly magazine Le Sourire, and writes for Les Guêpes. This leads to a further decline in relations with the colonial authorities and the bishop.

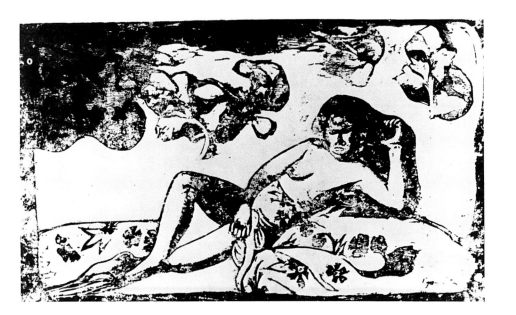

1899

On 19 April Pau'ura gives birth to their second child. Their son is named Emile.

1900

Contract with the Parisian art collector Ambroise Vollard. Gauguin commits himself to produce twenty five paintings for each of which he is to receive 250 francs. This is the first time that he is able to make a living from his art.

1901

In January Gauguin has to spend another lengthy spell in hospital. In September Gauguin heads for Hiva Oa, one of the Marquesas Islands lying almost 1000 km east of Tahiti. With the help of locals he builds his *Maison du jouir* in the bay of Atuona. He once again takes up residence with a young girl. Gauguin defends the Tahitians in numerous trials which leads to further disputes with the colonial authorities.

Te arii vahine
Woodcut, 1896

1902

Gauguin toys with the idea of returning to France due to his ever deteriorating health. Daniel de Monfreid dissuades him by saying that he no longer belongs to the contemporary art world, having entered into the annals of art history.

1903

In March Gauguin faces a fine of 500 francs and is sentenced to three months in gaol for slandering the colonial government. His health deteriorates dramatically. He dies on 8 May in his hut on Atuona, and is buried the following day in the catholic graveyard on Hiva Oa.

Gauguin's grave in the catholic graveyard on Hiva Oa

Self-Portrait, 1903
16½ x 17 ¾ in. (42 x 45 cm),
Kunstmuseum Basel

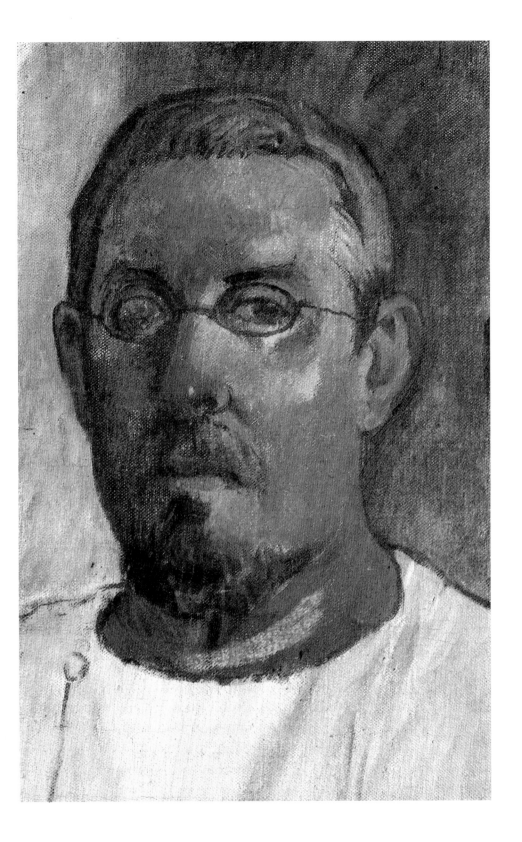

Notes

1. Georges Boudaille, *Gauguin*, Paris, n.d., p. 114

2. Pola Gauguin, *My Father Paul Gauguin*, trans. Arthur G. Chater, London 1937, p. 121

3. Ibid., p. 123

4. Michel Hoog, *Paul Gauguin*, Munich 1987, p. 80

5. Albert Aurier, *Le symbolisme en peinture: Paul Gauguin*. In: *Mercure de France*, p. 155ff., Paris, March 1891. Henri Perruchot, *Gauguin*, Munich and Esslingen 1991, p. 238

6. Michel Hoog, *Paul Gauguin*, p. 80

7. *Paul Gauguin 1848–1903*, Marla Prather and Charles F. Stuckey (eds.), Cologne 1994, p. 132

8. Pola Gauguin, *My Father*, pp. 128–29

9. *Lettres de Paul Gauguin à Emile Bernard*, with a text by Emile Bernard, Geneva 1954

10. Henry Perruchot, *Gauguin*, Munich, 1991, pp. 235–36

11. Pola Gauguin, *My Father*, pp. 141–42

12. Ibid.

13. Georges Boudaille, *Gauguin*, p. 134

14. Paul Gauguin, *Noa Noa*, Jean Loize (ed.), Munich 1969, p. 8

15. Ibid., p. 28

16. Ibid., p. 42

17. Ibid., p. 44

18. Michel Hoog, *Paul Gauguin*, p. 141

19. Paul Gauguin, *Noa Noa*, Pierre Petit (ed.), Munich 1992, p. 8

20. *Lettres de Paul Gauguin à sa femme et à ses amis*, Paul Malingue (ed.), Paris 1946

21. Günter Metken, *Gauguin in Tahiti*, Munich 1989, p. 15

22. Ari Redon and Roseline Bacon, *Lettres à Odilon Redon*, Paris 1960, p. 193

23. cf. Françoise Cachin, *Gauguin*, Paris 1988, pp. 169ff.

24. cf. Bengt Danielsson, *Gauguin in the South Seas*, 1965

25. Henri Perruchot, *Gauguin*, p. 267

26. See n. 20

27. *Paul Gauguin, Briefe an Daniel de Monfreid*, Kuno Mittelstädt (ed.), Berlin 1962, p. 34

28. Pierre Petit (ed.), *Noa Noa*, p. 128

29. Kuno Mittelstädt (ed.), *Briefe*, p. 179

30. Michel Hoog, *Paul Gauguin*, p. 224

31. Prather and Stuckey (eds.), *Paul Gauguin*, p. 146

32. For the history of the manuscript, see Jean Loize (ed.), *Noa noa*, pp. 9ff., and Pierre Petit (ed.), *Noa noa*, pp. 12ff.

33. Ibid.

34. Jean Loize (ed.), *Noa Noa*, p. 70

35. Wilhelm Uhde, *Von Bismarck bis Picasso*, Berlin 1929, p. 35

36. *Paul Gauguin, Vorher und Nachher*: excerpt from the manuscript *Avant et Après* by Erik-Ernst Schwabach, Munich,1920, pp. 35ff.

37. *Echo de Paris*, 13 May 1895

38. Kuno Mittelstädt (ed.), *Briefe*, pp. 53–54.

39. *Paul Gauguin, Vorher und Nachher*, Erik-Ernst Schwabach, Munich 1920, p. 169

40. Georges Boudaille, *Gauguin*, p. 213

41. Paul Gauguin, *Avant et après*, Leipzig 1928 (facsimile)

42. *Vorher und Nachher*, p. 10

43. Ibid., p. 159

44. Ibid., pp. 159–60

45. Ibid., p. 62

46. Ibid., pp. 11–12

47. Ibid., p. 12

48. Ibid., pp. 49–50

49. Ibid., p. 121

50. Ibid., p. 66

51. Ibid., p. 48

52. Ibid., p. 225

53. Ibid., p. 238

54. Ibid., p. 239

55. Ibid., p. 231

56. Kuno Mittelstädt (ed.), *Briefe*, p. 95

57. Ibid.

58. *Vorher und Nachher*, p. 228

59. Ibid., p. 187

60. Georges Boudaille, *Gauguin*, pp. 238–39

61. *Vorher und Nachher*, p. 223

62. Wilhelm Uhde, *Von Bismarck bis Picasso*, p. 47

63. Kuno Mittelstädt (ed.), *Briefe*, p. 236

64. Ibid., p. 192

65. Georges Boudaille, *Gauguin*, p. 262

66. *Vorher und Nachher*, pp. 225, 229

List of illustrations

Photographic credits

Photographie Giraudon, Paris Pages 20/21, 25,
27, 29, 30, 31, 36, 40, 41, 58, 64, 65, 66/67, 69, 70,
71, 76, 77, 79, 80, 83, 84/85, 90, 96, 100

Musée Gauguin, Papeete, Tahiti: Photographs on
pages 22, 78, 87, 92, 97, 108

© Prestel Verlag, Munich · London · New York, 2001
(first published in 1996)

Front cover: *When will you marry?* 1892, detail
 Kunstmuseum Basel
Spine: *Self-Portrait with Palette, c* 1894, detail
 Private Collection, New York
Frontispiece: Watercolour on page 124
of the artist's book *Noa Noa*, detail
 Musée du Louvre, Paris

Translated from the German by Fiona Elliott
Edited by Simon Haviland

Prestel Verlag
Mandlstrasse 26 · 80802 Munich
Tel. (089) 381709-0, Fax (089) 381709-35;
4 Bloomsbury Place · London WC1A 2QA
Tel. (0171) 323 5004, Fax (0171) 636 8004;
16 West 22nd Street · New York, NY 10010
Tel. (212) 627-8199, Fax (212) 627-9866

Prestel books are available worldwide.
Please contact your nearest bookseller
or one of the above Prestel offices for
details concerning your local distributor.

Die Deutsche Bibliothek – CIP-Einheitsaufnahme and
the Library of Congress Cataloging-in-Publication data
is available

Typeset and designed by WIGEL, Munich
Cover design: Matthias Hauer (paperback)
Typeface: Janson Text and Akzidenz Grotesk BQ
Printed by Passavia Druckservice GmbH, Passau
Bound by Conzella, Pfarrkirchen

Printed in Germany on acid-free paper

ISBN 3-7913-1673-7 (hardcover)
ISBN 3-7913-2589-2 (paperback)